POSTCARD HISTORY SERIES

Bedford

POSTCARD HISTORY SERIES

Bedford

Alethea A. Yates

ARCADIA
PUBLISHING

Published by Arcadia Publishing
Charleston, South Carolina

Printed in the United States of America

Library of Congress Control Number: 2013930705

For all general information contact Arcadia Publishing at:
Telephone 843-853-2070
Fax 843-853-0044
E-mail sales@arcadiapublishing.com
For customer service and orders:
Toll-Free 1-888-313-2665

Visit us on the Internet at www.arcadiapublishing.com

*To my beloved husband, Lee R. Walus, and to the past,
present, and future people of Bedford, Massachusetts*

CONTENTS

ACKNOWLEDGMENTS

This book became possible only with the assistance of many people from the little town that we love best. The author would like to express her gratitude to Donald Corey and Sharon Lawrence McDonald for their invaluable review of the text; to Niki Beechwood Curry for her proofreading skills; to Rev. John Gibbons, Rev. Lorrie Dunham, Richard L. Axtell, Amy Lloyd, the Bedford Historical Society, and Carleton-Willard Village for providing postcards; to John Dodge, Judith Lindau McConnell, John Ridgway Comley III, and Richard Wolf for sharing their historical expertise; to Fay Russo, Kara Kerwin, Deb Koury, Dr. Louis Pitt, and James Shea for lending their time and assistance; and especially to Lee R. Walus, without whose research assistance, enthusiasm, patience, and loving support this book would never have been completed.

All images appear courtesy of the author except where indicated as follows: the Bedford Historical Society (BHS), Rev. John Gibbons (JG), Rev. Lorrie Dunham (LD), Richard L. Axtell (RA), and Carleton-Willard Village (CWV).

INTRODUCTION

How did Bedford, Massachusetts, come to appear on so many postcards? Let us consider some of the ingredients of Bedford's history.

First, there was the land. It was sufficiently fertile to be desirable to settlers in the early 17th century. There were some fast-flowing streams to run the gristmills, essential to early New England life. The land was fairly level, suitable for plowing, and most of it was upland rather than low-lying swamp. Farmers settled and built houses, sowed crops, and raised families. Another feature of the land was a geological quirk: mineral springs that gained a reputation for possessing healing properties. In 1843, the Springs Hotel was opened to accommodate the many visitors to Bedford's famous waters.

For more than two centuries, Bedford remained primarily a farm town, growing very slowly over the years. It had all the charms of a small rural community: old New England houses, old New England traditions, winding country roads, and a picturesque village center with a church on the Town Common. Some wealthy Bostonians found themselves drawn to these charms. Among them was Charles Jenks, a Boston businessman who withdrew from his profession and became a gentleman farmer in Bedford when he inherited Fitch Tavern.

A very important factor in Bedford's history has always been the town's proximity to Boston. From the earliest farming days, Boston was a market for Bedford's farm products and firewood. When the railroad came in 1873, Bedford was drawn closer to the city. A few factories, such as the Bedford Safety Razor Company, sprang up near the station, and this became the town's industrial and transportation center. Meanwhile, the small business district that ran from the common westward and along North Road to the intersection of Carlisle Road continued in operation, but it changed very little in the century that followed. The rest of the area around the Town Common remained mostly residential. The train also made it practical for some people to live in Bedford and work in Boston; for example, Arthur W. Blake, who built Fairwick on Hillside Avenue. A few mansions were built on extensive grounds, and as some of them became available for purchase, they were acquired by institutions that relished the country air and seclusion. Examples of these are the Willard Hospital, Llewsac Lodge, and the Maryvale Seminary.

Bedford drew even closer to Boston with the coming of the Lexington & Boston Street Railway in 1900. Because Bedford had a suitable tract of woodland along the streetcar line and was midway between Boston and Lowell, it was an ideal place for a seasonal amusement park. Lexington Park gave city and country people from all walks of life the chance to spend a pleasant and relaxing day in the shade and the fresh country air. Another recreational opportunity came when streetcars began bringing out-of-towners to a small district of summer cottages along the Concord River.

It was not country charm or rural quiet but large tracts of affordable land near Boston that brought two major institutions. The federal government bought two adjoining properties on Springs Road and opened the US Veterans' Hospital in 1928. Bedford's officials had campaigned strenuously to have the town chosen as the site. In 1941, the federal government, seeing a need for a second airport in the Boston area, built a civilian airport on land that the state was able to acquire through eminent domain. The thinly populated southern end of Bedford, with some farmland and much scrubland, was chosen as the airport site despite the opposition of Bedford residents.

The most important factor throughout Bedford's history has been the spirit of its people. From the earliest days of the Massachusetts Bay Colony, they had governed themselves. In 1729, a handful of families in a thinly settled area received permission to incorporate the Town of Bedford. This meant that they had to find the resources among themselves to build a meetinghouse, hire and pay a minister, start a school, and elect a full complement of town officials. Their tradition of self-government gave them the confidence and skill to do this for themselves. When this tradition was put to the test in 1775, nearly every able-bodied Bedford man of military age took up arms to defend it. Bedford is very proud of its founders and defenders, as can clearly be seen in images of their houses and the sites associated with the American Revolution. Today, Bedford's people still participate in the world's purest form of democracy, the open town meeting. All of Bedford's registered voters can participate, speak their minds, and help to set the course for their community.

Bedford's churches have played a central role. The town's original parish divided itself between Congregationalists and Unitarians in the 1830s. By the 1880s, the town's Yankee farmers had been joined by enough Catholic immigrants from Ireland and elsewhere to support a Catholic chapel.

Bedford people have always been community-minded. This can be seen not only in town government but also in the town's social organizations. For example, one of the largest and most active groups was the Bedford Grange. From 1909 until the middle of the 20th century, most of the town belonged to the grange. This and many other social groups have contributed to Bedford's vibrant community life.

For much of its history, Bedford was very conservative, and the majority of the voters were Republicans. Bedford was a temperance town, prohibiting the sale of liquor from 1888 to 1913.

The post–World War II construction boom brought profound change to Bedford. Farmers found that their greatest source of profit was not agricultural products but house lots. Bedford's population surged. Houses, schools, churches, and industrial and commercial buildings were erected in record numbers. Bedford finally had enough schoolchildren to fill a high school of its own. Motels and shopping centers were built along the Great Road. Through it all, Bedford's residents managed to do some very effective planning. They also put a great deal of effort into historic preservation. Today, industrial parks are tucked into the landscape, mostly in peripheral areas of the town. The bulk of the retail district has moved to the eastern end of the Great Road, leaving the original village center around the Town Common looking much the same as it did 100 years ago. Though no longer a small farming community, Bedford still retains much of its New England village charm.

One

ECHOES OF THE
REVOLUTION

Bedford is proud of its role in the American Revolution. In the night hours of April 18–19, 1775, Benjamin Tidd and Nathaniel Monroe of Lexington rode to the Bedford home of Cornet Nathaniel Page (the house was renovated in 2011 by the television show *This Old House*) and woke him with the news that the Regulars were on the march to capture military supplies hidden in Concord. He went to the gathering place of Bedford's fighting men at the Fitch Tavern and, according to tradition, took the Bedford Flag with him. Jonathan Wilson, captain of the Minutemen, rallied his men with fighting words before they marched to Concord, perhaps meeting up with more Bedford men at the home of John Moore, their militia captain. Together, 77 of Bedford's men, from a population of only a few hundred people, marched to Concord and joined the fighting.

Today, echoes of the Revolution can still be heard. Some of the homes of the Revolutionary soldiers are still standing. The fields they plowed and the roads they traveled are all around. Their actions are recollected each year at the Pole Capping ceremony. Most important, the rights for which they fought—especially the right to manage their own affairs through Bedford's town meeting—are still in use today. And above it all flies the Bedford Flag.

Bedford's civic pride is embodied in the Bedford Flag. Created to be carried by the king of England's troops, it ironically ended up being carried by the king's opponents. Page family tradition has it that Cornet Nathaniel Page carried the flag as Bedford's fighting men marched to Concord on April 19, 1775. It is the oldest intact flag in the United States.

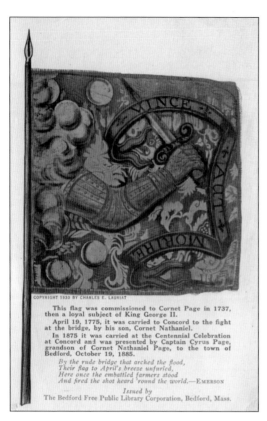

COPYRIGHT 1930 BY CHARLES E. LAURIAT

This flag was commissioned to Cornet Page in 1737, then a loyal subject of King George II.

April 19, 1775, it was carried to Concord to the fight at the bridge, by his son, Cornet Nathaniel.

In 1875 it was carried at the Centennial Celebration at Concord and was presented by Captain Cyrus Page, grandson of Cornet Nathaniel Page, to the town of Bedford, October 19, 1885.

By the rude bridge that arched the flood,
Their flag to April's breeze unfurled,
Here once the embattled farmers stood
And fired the shot heard 'round the world.—EMERSON

Issued by
The Bedford Free Public Library Corporation, Bedford, Mass.

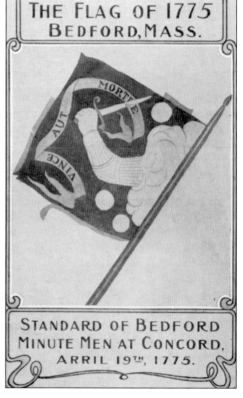

THE FLAG OF 1775
BEDFORD, MASS.

STANDARD OF BEDFORD
MINUTE MEN AT CONCORD,
ARRIL 19TH, 1775.

"Conquer or die," commands the motto on the Bedford Flag. The sword-bearing arm emerging from a cloud is meant to represent the Almighty. The significance of the three silver spheres has not been determined. Roughly square in shape and relatively small, the flag was meant to be carried by a cavalry officer on horseback. Its original silver fringe has been lost.

The Bedford Flag suffered damage over the years, as seen here. In 1998, the Bedford Free Public Library and the Friends of the Bedford Flag began raising funds to have the flag cleaned and conserved, a painstaking process that took more than two years. The Bedford Flag now resides in a specially designed room in the Bedford Library. (BHS.)

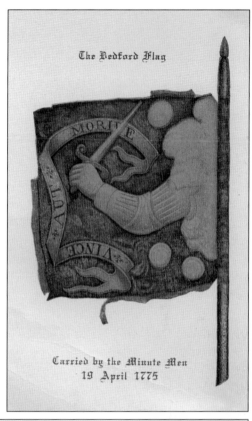

The Bedford Flag

Carried by the Minute Men
19 April 1775

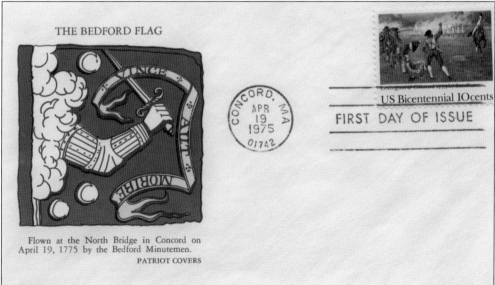

THE BEDFORD FLAG

Flown at the North Bridge in Concord on April 19, 1775 by the Bedford Minutemen.
PATRIOT COVERS

In 1885, Cyrus Page, grandson of Cornet Nathaniel Page, presented the Bedford Flag to the Town of Bedford. Now part of the town seal, the flag's image appears on the town's stationery, motor vehicles, and everything else belonging to the town. Nothing says Bedford like the revered Bedford Flag. This is a first day cover issued on April 19, 1975, the bicentennial of the Battles of Lexington and Concord.

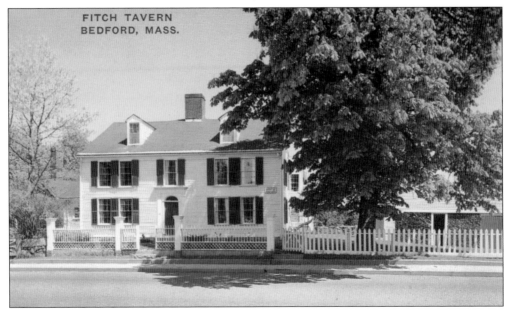

FITCH TAVERN
BEDFORD, MASS.

Fitch Tavern, built around 1730, played a notable part in the events of April 19, 1775. It was the prearranged gathering place of Bedford's fighting men before they marched to the Battle of Concord. Jeremiah Fitch, who owned the house at the time, used part of his home as a tavern.

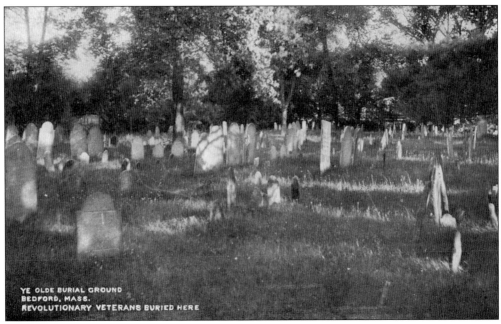

YE OLDE BURIAL GROUND
BEDFORD, MASS.
REVOLUTIONARY VETERANS BURIED HERE

The Old Burying Ground on Springs Road, the resting place of Bedford's Revolutionary War soldiers, was the town's only cemetery from 1730 until 1849, when Shawsheen Cemetery was opened. In 1896, a monument was placed here to honor Cambridge Moore, Caesar Prescott, and Caesar Jones, who had been slaves but served as soldiers in the Revolution. A monument to Job Lane was unveiled in 1902.

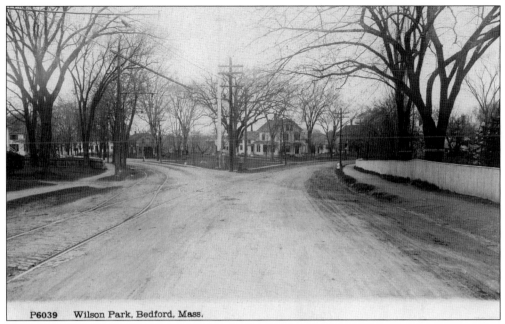

P6039 Wilson Park, Bedford, Mass.

Wilson Park, the triangular plot of land where the Great Road divides into Concord Road (left) and North Road, honors Jonathan Wilson, the captain of Bedford's Minutemen. His brave boast to his men before the Battle of Concord—"We'll have every dog of them before night"—was sadly ironic. By that night, he had become the only Bedford man to lose his life in the battle.

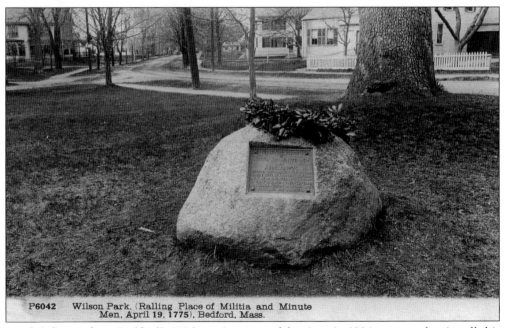

P6042 Wilson Park. (Ralling Place of Militia and Minute Men, April 19, 1775), Bedford, Mass.

Funds left over from Bedford's 175th anniversary celebrations in 1904 were used to install this small monument to mark Wilson Park as the "rallying place of Militia and Minutemen, April 19, 1775." The tree directly behind the monument was the Old Oak. The houses in the background are all still standing on North Road.

13

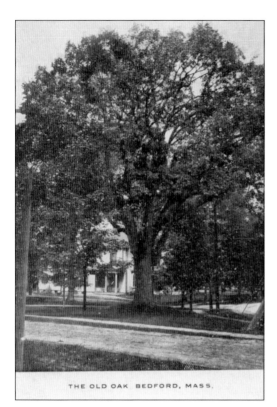

THE OLD OAK BEDFORD, MASS.

The Old Oak was associated with the gathering of Bedford's Minutemen on April 19, 1775, but its size in this photograph suggests that it was too young to have been standing in 1775. It was definitely part of another historic event, the Hurricane of 1938, when it was toppled. A new oak tree has been planted in its place. (BHS.)

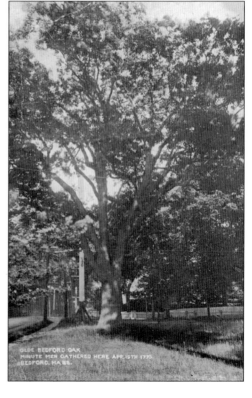

This view of the Old Oak in Wilson Park includes a flagpole at the Great Road end of the park. This triangular park was not always the hallowed spot it is today. For many years, it was a just a bit of neglected ground at the junction of three roads. In the 1880s, the Village Improvement Society had it tidied and landscaped. (RA.)

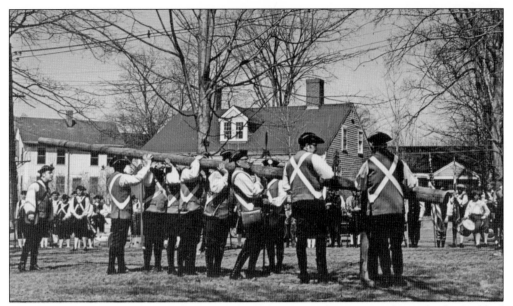

The liberty pole in Wilson Park is the center of the town's festivities each April. The Bedford Minuteman Company was reestablished by the selectmen in 1964 to honor the town's Revolutionary history. Just before each Patriots' Day, these uniformed reenactors perform the Pole Capping ceremony, in which they raise the liberty pole and top it with a red cap as a symbol of resistance to tyranny. (BHS.)

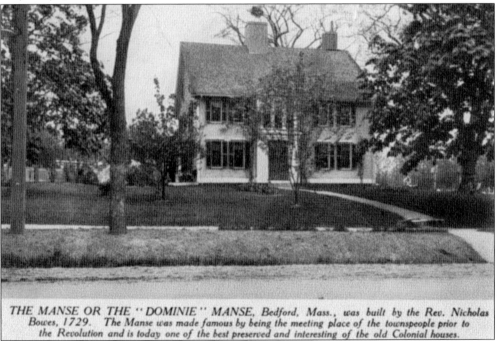

THE MANSE OR THE "DOMINIE" MANSE, Bedford, Mass., was built by the Rev. Nicholas Bowes, 1729. The Manse was made famous by being the meeting place of the townspeople prior to the Revolution and is today one of the best preserved and interesting of the old Colonial houses.

At the time of the Revolution, Domine Manse was the home of John Reed. He represented the town at meetings of the Provincial Congress and allowed his home to be used for clandestine meetings of Bedford's Committees of Correspondence and Safety as they helped to plan the rebellion. (JG.)

THE OLD GARRISON HOUSE, BEDFORD, MASS.

This was the home of several generations of men named Job Lane. Lt. Job Lane, who grew up here, fought at the Battle of Concord and was so severely wounded that he became a government pensioner. His father, Deacon Job Lane, built the right-hand half of this house in about 1713 on land passed down from his grandfather, also named Job Lane. (BHS.)

The Old
Garrison House,
Bedfort, Mass.
Built in 1667.

Job Lane, the grandfather of Deacon Job Lane, was a native of Rickmansworth, England. Beginning life as a humble working man, he prospered and made his son John a wealthy gentleman. John, in turn, made all of his sons and daughters landowners. The second half of the house, to the left of the front door, was added by Oliver Abbott around 1827. (BHS.)

16

Two

THE VILLAGE CENTER

In 1729, the founders of Bedford chose the highest spot near the middle of the new town as the site to raise their church, thus making the area around it the village center. As the town grew, the business district began to develop along the roadway from the Common northwest along North Road about as far as Carlisle Road. This remained the locus of business activity in Bedford until the 20th century. The town's first two churches, first all-in-one elementary school, first junior high school, first high school, and first two town halls were built in the center. Of those buildings, all but the first church are still standing.

What is most remarkable about the village center is how little it changed in the 20th century. The majority of the buildings present in 1900 are still in place today. Scenes in the earliest postcards are readily recognizable.

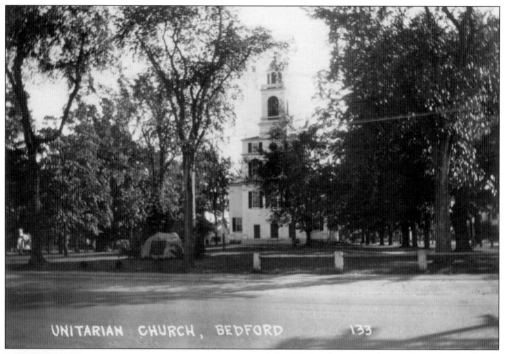

UNITARIAN CHURCH, BEDFORD 133

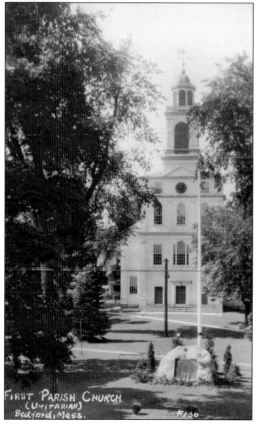

FIRST PARISH CHURCH
(UNITARIAN)
Bedford, Mass.

The Unitarian church stands at the back of the Town Common. When Bedford was founded in 1729, the Common was much larger. It changed size and shape over the years, settling into its current configuration by 1860. It has been the site of the town's original church, a schoolhouse, a fire bell, and the town pound. The Common has had fencing with stone posts and wooden rails since the 1850s.

The boulder on the Town Common honors Bedford residents who served in World War I. It was found on land belonging to Charles Jenks and transported by the Boston Safe & Machinery Movers. A bronze plaque was affixed to the boulder, and it was dedicated on July 4, 1925, with a grand parade, speeches, and a banquet. Ceremonies were concluded with "three cheers and a tiger." (BHS.)

Glimpse of the Common, Bedford, Mass.

The children in this postcard are walking along the Town Common in front of the Unitarian church. In the background is the original section of the Fletcher Block. The name over one of the stores appears to be Ruderman's. The tree on the left is a horse chestnut in bloom. (LD.)

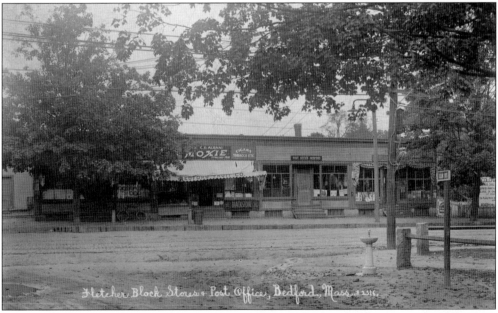

This is the Fletcher Block. Only the stores of the wooden section, built around 1895, are present. The signs visible over the stores are, from left to right, "C.D. Albani" (the awning says "Bedford Fruit Co."), "Post Office Bedford," and an obscured name, possibly Elmer Blake's grocery store. (BHS.)

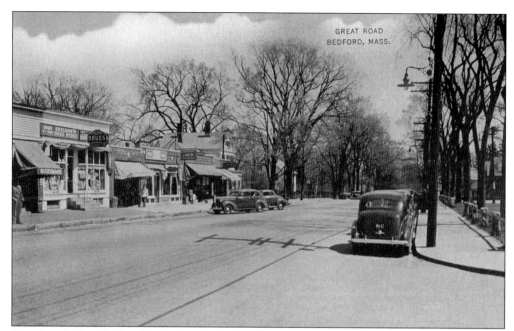

Seen here is the Fletcher Block after the brick section was added in the 1920s. The stores in this photograph include Ruderman's (left), Sheldon's Drug Store, an unidentified lunch establishment, and the Atlantic & Pacific Tea Company (A&P). Note that the road has been paved and the streetcar tracks removed.

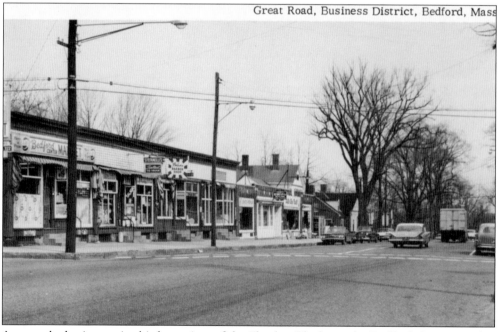

Among the businesses in this later view of the Fletcher Block are the Bedford Center Market (left), Stefanelli's, Poleo's Barber Shop, a shoe repair outlet, and Dutch Boy Paints. Stefanelli's acquired Albani's fruit store in 1928 and ran it until 1978. The Fletcher Block was demolished on August 17, 2011.

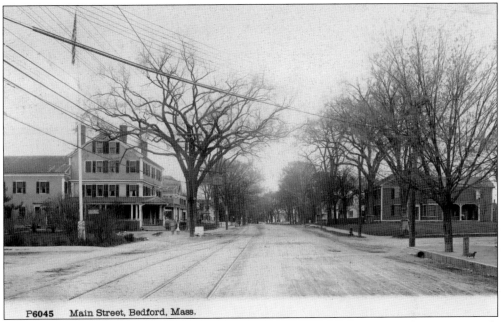

P6045 Main Street, Bedford, Mass.

This view of Main Street includes, at left, the Bedford House hotel. Today, the fire station stands on that spot. A 1902 magazine article described the hotel as "a distinctly first-class, finely-equipped hotel. . . . The Bedford House contains 24 sleeping rooms [and] all the modern improvements, such as steam heat, hot water, etc., etc., and ample stable accommodation. The cuisine is excellent, and as a summer resort the Bedford House is unexcelled anywhere."

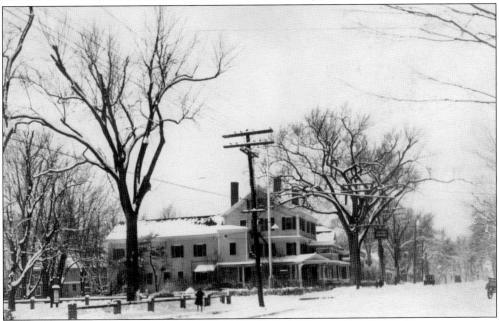

In its day, Bedford House was the town's only year-round hotel and one of Bedford's most notable attractions. Among its guests were the New England Fox Hunter's Club, when it gathered for its annual winter hunts across the fields of Bedford and surrounding towns. Its master of hounds, William B. Simonds, was a Bedford man.

21

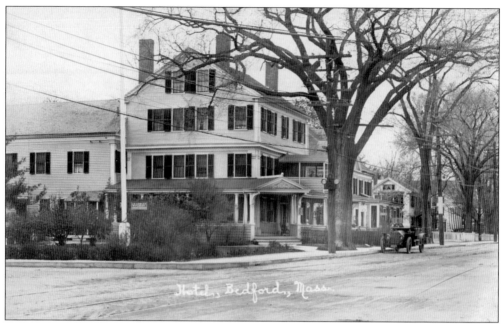

In 1920–1921, the Bedford House hotel was also a training center for professional boxers. Johnny Wilson, the reigning middleweight champion, trained here for some of his most important bouts. Among the others who used the facilities were Tommy "Young Kloby" Corcoran, Abel Friedman, Frank Tillo, Cleveland Johnny Downs, Paul Doyle, and Danny Krammer.

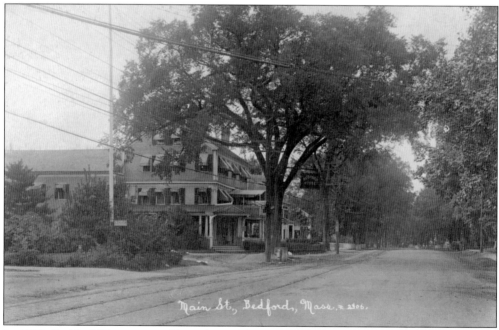

In 1925, Bedford House was sold to the Bedford Grange. This gave the very active group a place of its own to hold movie screenings, dinners, the annual fair, and a multitude of other events. It also resolved the ongoing conflict between the town and the hotel over the sale of alcoholic beverages.

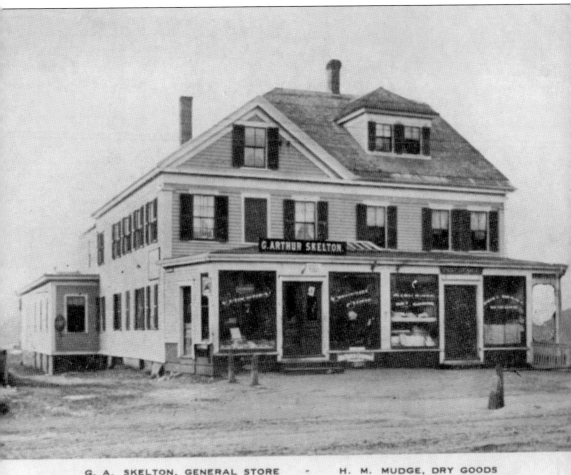

G. A. SKELTON, GENERAL STORE - H. M. MUDGE, DRY GOODS

BEDFORD, MASS.

This was the site of two long-remembered stores. On the right was the dry goods store and post office of Harriet M. Mudge, Bedford's first female postmaster. Penny candy made her shop a favorite with schoolchildren. Bequests left by Harriet and her sister Rebecca established the Mudge Fund to provide recreational opportunities for children, such as the playground to the west of the Center School. The road that runs past the playground was named Mudge Way in their honor. On the left side of this building was George Arthur Skelton's General Store. In his book *An Amazing Century*, Williston Farrington recalled that Skelton's had horsewhips and quirts just inside the front door, canned goods on the left, hardware in back, and a fish store in the basement. This building is still standing at 47-53 The Great Road. The left half of the building (the Skelton store) was built around 1884, and the right half (the Mudge store) was added later. (LD.)

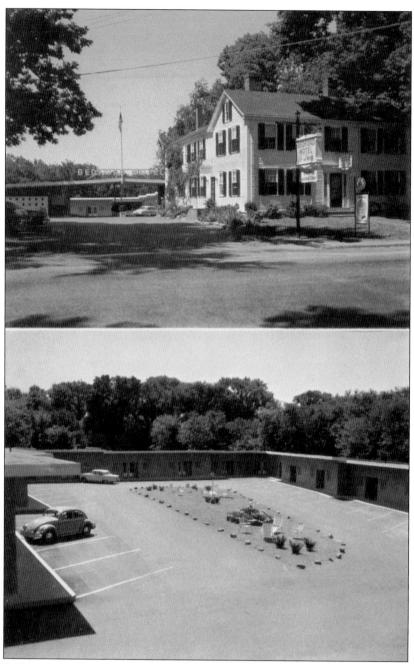

The Bedford Inn at 30 North Road, standing directly in front of the Bedford Motel, was for many years a restaurant run in conjunction with the motel. It was built as the home of Jonas Munroe (1795–1879). Murals attributed to itinerant artist Rufus Porter decorated its walls. A portion of a mural was saved before the building was demolished in 1971 and is today on display in the town hall auditorium. In a 1963 article, the *Boston Globe* said, "During the past 10 years the Bedford Motel, with its accompanying gourmet restaurant, has become the home away from home for many of the scientists and businessmen who must visit the Route 128 area. . . . Each of the 50 rooms is a spacious 26 by 32 feet. . . . There is a courtyard where adults may sun and relax."

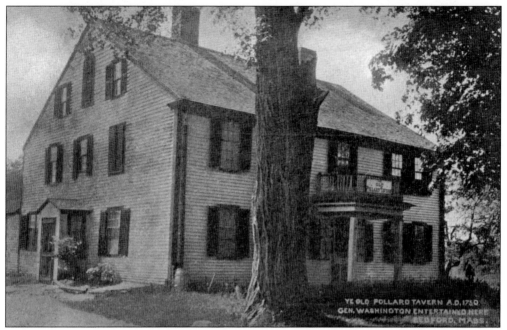

The Pollard Tavern stood approximately where 40 North Road is today. Walter Pollard operated the tavern in the years just after, and perhaps even before, the town's founding in 1729. The selectmen sometimes held their meetings here. Contrary to the postcard's caption, Gen. George Washington did not entertain here. The tavern was demolished around 1930.

This house, which stood on North Road across from the Pollard Tavern, was built by wheelwright Samuel Sage. His son, Samuel Sage VIII, served briefly in the Civil War. It was later the home of Joseph Goodwin and his wife, then of Frisbie Proctor and his family. Proctor's daughter Blanche was the last resident. In 1991, the house was moved to Carlisle, Massachusetts. (BHS.)

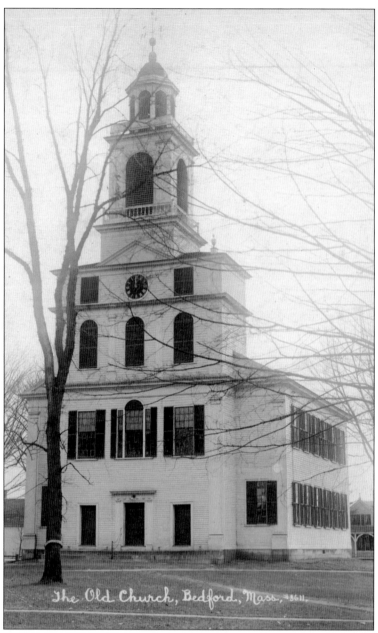

The Old Church, Bedford, Mass. 16011.

The church on the Town Common was built in 1817 using materials salvaged from the town's original church, which stood 40 feet away in what is now the northwest corner of the Common. The structure, with its distinctive four-story entry bay, is thought to have been based on a design by noted architect Asher Benjamin. This church, like the one that preceded it, was built by its Congregational parishioners in an era when the Congregational Church was the tax-supported, established church of Massachusetts. There was no separation of church and state; the church belonged to the town, and its minister was a town employee. After this structure became a privately owned Unitarian church in the early 1830s, the question of who owned the Common on which the church stood became a problem. A dividing line that split ownership between town and church was finally settled in 1976. (BHS.)

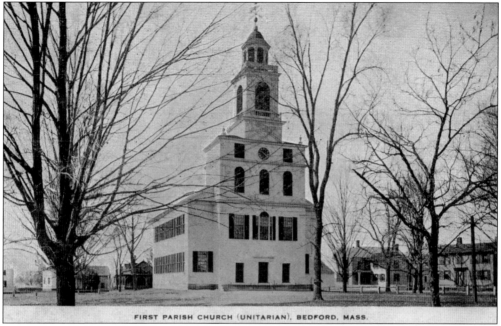

FIRST PARISH CHURCH (UNITARIAN), BEDFORD, MASS.

Behind the church on the Common, the houses on Maple and Elm Streets look much the same on this postcard as they do today. Seen here are 4 (left), 6, and 8 Maple Street to the left of the church, 29 Elm Street just to the right of the church, and the double house at 21-23 Elm Street. Builder Joshua Page is thought to have introduced double houses to Bedford Center around the 1830s. Several are still standing. (BHS.)

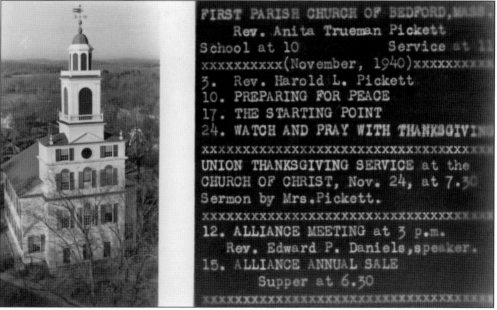

In 1940, the government constructed a tower on the Town Common to take a geodetic survey. Alfred Webber climbed the tower and took photographs of the surrounding area. This view of the Unitarian church is particularly striking. Rev. Anita Trueman Pickett included a photograph with each of her monthly postcards announcing upcoming services and events. (JG.)

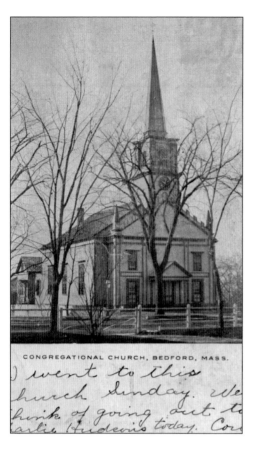

CONGREGATIONAL CHURCH, BEDFORD, MASS.

I went to this church Sunday. We think of going out to Carlie Hudson's today. Cor

This is an early view of the Congregational church. In the early 1830s, Bedford's original parish divided itself between the newer Unitarians, who retained ownership of the church on the Town Common, and the more traditional Congregationalists, who built this church in 1832. While it was under construction, Rev. Samuel Stearns held services in his home across the street.

This postcard of the Congregational church shows two features of the 1886 renovation: the steeple that was added to the square bell tower and a gabled porch. The porch covered the unusual decorative scrollwork around the front door, but the scrollwork has since been restored. The church's electric carillon was a 1935 gift from Myron H. Clark and his wife in honor of his parents and uncle. (BHS.)

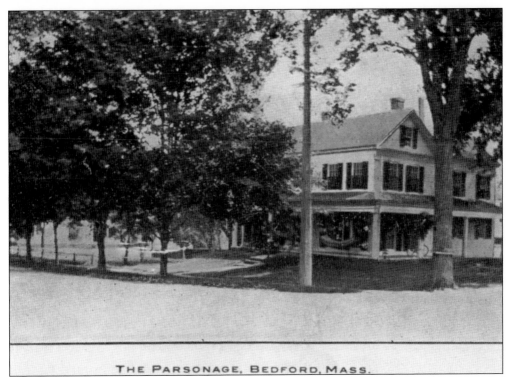

THE PARSONAGE, BEDFORD, MASS.

This house originally stood on the east corner of the intersection of Main Street and South Road. For more than 60 years, it was the parsonage of the Congregational church. In the 1920s, it was moved down the street to the corner of Bacon Road, where it now houses professional offices at 143 The Great Road.

The First Parish Church, Bedford, Mass.

The Parish Committee of the First Parish Church of Bedford, Mass., announces a series of Union services with the Church of Christ during July and August, and urges your attendance at all the services that you can attend.

July 6, thru August 3, at the Unitarian Church
August 10, thru August 31, at the Congregational Church.

For a period during the 1930s and 1940s, the Congregational and the Unitarian churches in the center held joint services in the summertime. This permitted each minister to take a vacation while services continued. The religious views of the two congregations were similar enough to make this feasible. (BHS.)

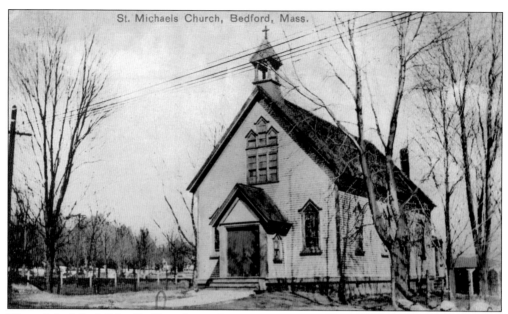

The original St. Michael's Church stood on Main Street at the corner of Hillside Avenue. It was built in 1884 as an unstaffed chapel to serve the needs of Bedford's Catholic community. A priest came from St. Brigid's Church in Lexington to conduct services. An 1894 business directory stated that masses were said by Rev. P.J. Kavanaugh at 9:00 a.m. and 10:30 a.m. every other Sunday.

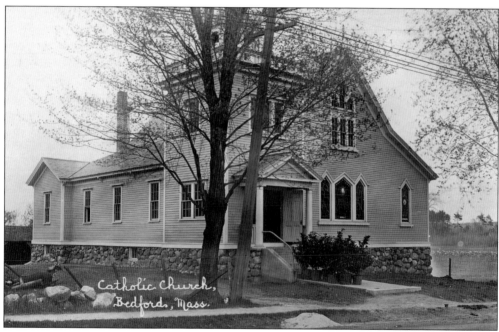

St. Michael's Church was enlarged in 1916 to accommodate its growing congregation. In 1931, it became the Parish of St. Michael, and a resident priest was assigned. In 1932, parishioners built a rectory behind the church for Rev. William Ulrich. The building seen here remained in operation until the current St. Michael's Church on Concord Road was opened in 1960.

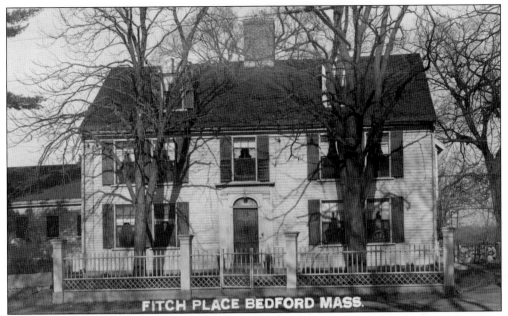

FITCH PLACE BEDFORD MASS.

The Fitch house was built around 1730 and might have been standing when the town was incorporated in 1729. Its original owner was Benjamin Kidder. Jeremiah Fitch Jr. bought it in 1766 and operated a tavern in the house. His son, also named Jeremiah Fitch, became a wealthy businessman in Boston and donated the land on which the current Congregational church was built.

JENKS PLACE, Bedford, Mass. One of the oldest houses in the village, built probably before 1738. Kept as a tavern in 1775 by Jeremiah Fitch, Jr., and the gathering place of the Militia and Minute Men on April 19th.

The Fitch property, also known as Stonecroft Farm, spanned several acres on both sides of Main Street. It was inherited by Jeremiah Fitch's great-grandchildren Charles W. Jenks and his sisters, Mary and Caroline Jenks. The three made it their home for many years. In 1926, Charles Jenks donated two acres as a site for the town's first junior high school, the building that now serves as town hall.

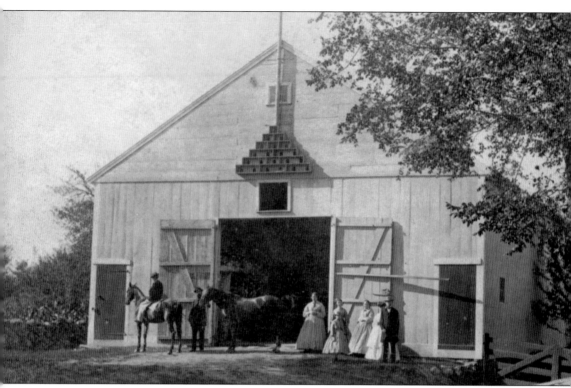

The Fitch barn stood across the street from Fitch Tavern, approximately at the head of today's Mudge Way. The cows could walk from the barnyard to the pasture in back, which stretched down to what is now Railroad Avenue. The two stone walls in front of today's library and high school mark the cow path. A small pond in the pasture provided water for the cattle. The triangular structure above the barn door is a dovecote, which provided nesting places for pigeons or doves. These birds were often kept for the eggs, meat, and fertilizer they provided. When Charles Jenks owned the property, he kept white fan-tailed pigeons in the barn. The date of this photograph is unknown, but the women's hoopskirts indicate that it is likely the 1860s or 1870s, when Caroline Fitch owned the property. (BHS.)

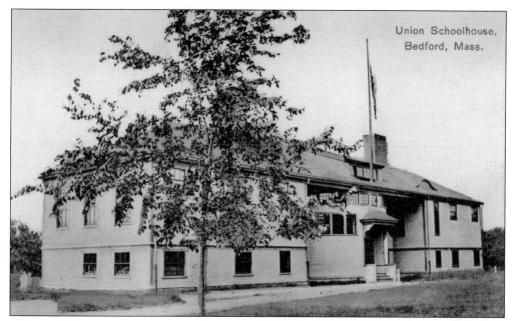

The Union School opened in 1892 to serve as the town's elementary school, replacing the North, South, East, West, and Center Schools. Note the semicircular entry bay and the eyebrow windows in the roof. The building originally had a third story, but it was removed after a fire. For a time, the school had a windmill to pump water into cisterns in the attic.

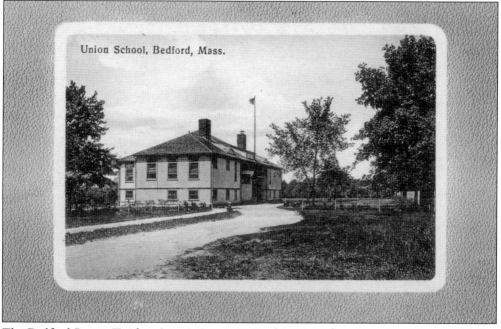

The Bedford Parent-Teacher Association, organized in 1910, found much to do at the Union School. It began selling hot cocoa to supplement the children's cold lunches, raised money for play equipment, arranged for a stock of children's books, gave the basement playroom a smooth cement floor, and, as the school committee reported in 1912, began "holding up the mirror" so the school committee could "see the blemishes and remove them."

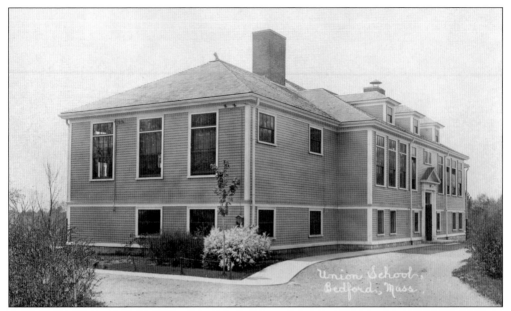

This is the Union School after the front entryway was altered. Many improvements were made in the early 20th century. Electricity and town water were installed. An in-school dental clinic treated the children in an era when there was no dentist in Bedford. The curriculum was coordinated with that of Lexington to prepare the children to attend Lexington High School in the years before Bedford had its own high school. (BHS.)

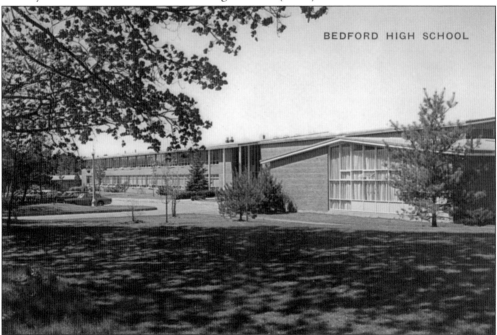

Bedford High School, opened in 1956, was the town's first high school building. The town had tried offering high school classes during the 1850s and again in the 1890s, but there were not enough students to make it practical. From 1901 to 1917, Bedford students attended high school in Concord; after 1917, they went to Lexington.

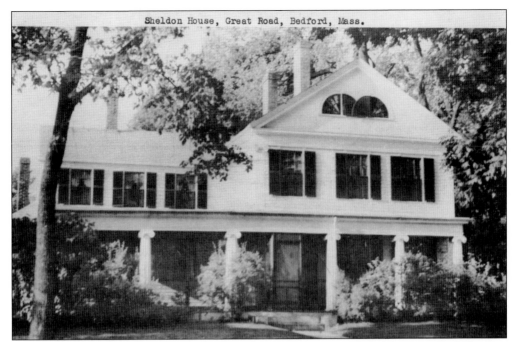

The Greek Revival house at 90 The Great Road (above) was built in the 1840s. One of its owners was Dr. Edward Hamblen, who made it his home and office. It later became known as the Sheldon House because of longtime resident Walter Sheldon and his family. He ran a pharmacy in the adjacent Fletcher Block. On the undated postcard below, a dogsled team runs past the house. It is not known why the team was in Bedford, but dogsleds were not uncommon in Massachusetts. In fact, a widespread interest in dogsled racing led to the founding of the New England Dog Sled Club in 1924. (Both, BHS.)

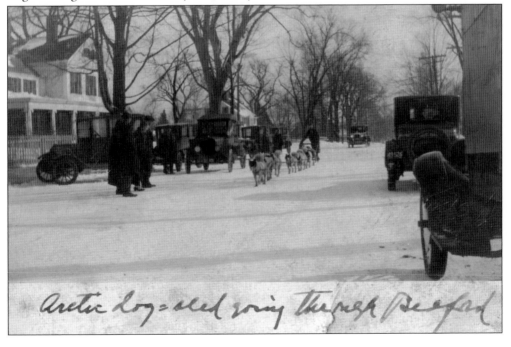

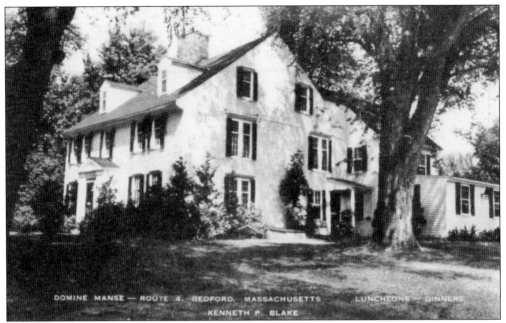

Domine Manse was built in 1730 by Bedford's first minister, Nicholas Bowes, on the 16 acres of land that the town granted to him. He purchased additional acreage and ran a farm in addition to performing his ministerial duties. The main block of the building (at left in the above photograph) was built by Reverend Bowes. It has had several additions over the years. In the 1940s and 1950s, the house was operated as a restaurant by Kenneth P. Blake. Glass-walled dining rooms and a conservatory were added to enhance the establishment. In the postcard below, restaurant tables are set on a brick patio. The conservatory can be seen through the windows at the left. Today, the house is operated as a suite of business offices. (Both, JG.)

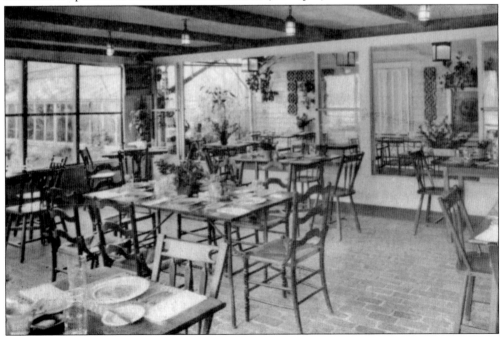

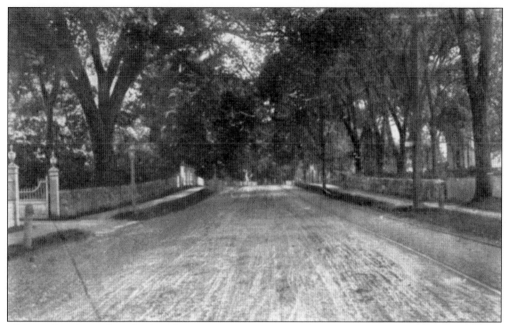

This is the Great Road, then known as Main Street, looking eastward. The door of the Congregational church can be glimpsed on the right. Trolley tracks for the Middlesex & Boston Street Railway run along the right side of the otherwise unpaved road. The gate on the far left opens onto the driveway of 4 The Great Road, known as the Squire Stearns House.

This is an eastward view of Main Street as it drops down toward Hillside Avenue and the railroad crossing. The house with a porch on the far right is 119 The Great Road, known as the William A. Putnam House. Just beyond it is 113 The Great Road, the D.P. Ladd House.

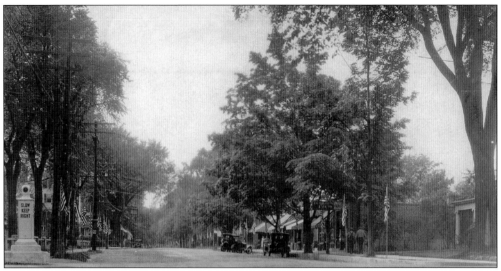

This view looks west along a tree-lined, flag-decorated Main Street. Beyond the parked cars are the Fletcher Block stores, shaded by striped awnings. The pillars of the Hartwell-Hamblen House appear on the far right. The Town Common is just out of sight on the left. Note the traffic signal (left), which stands in the middle of South Road where it meets Main Street.

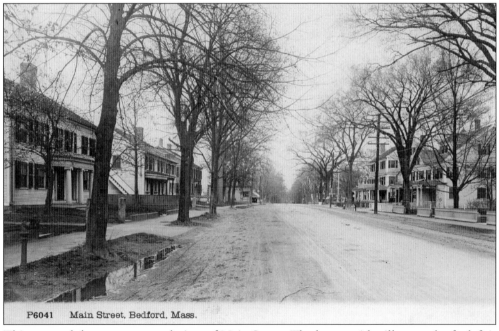

This postcard shows an eastward view of Main Street. The house with pillars on the far left is 32 Main Street; next to it is 48–52 Main Street, which now has a group of stores added to the front. On the far right is 47–51 Main Street; beyond it is the Bedford House hotel.

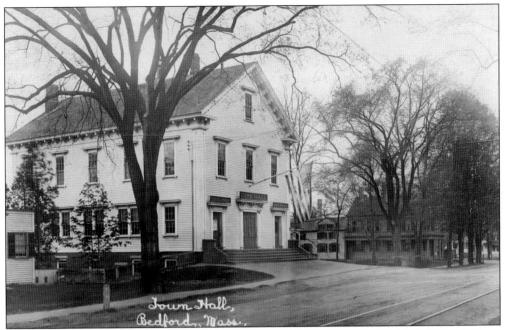

Built in 1856, the old town hall was originally a multipurpose building that housed town offices, two schoolrooms, and a large hall for town meetings and social gatherings. At various times, it also housed the police station, a jail cell, the town library, the Bedford Historical Society, the Bedford Grange, and a World War II recreation center for military personnel.

THE BIGGEST ANNUAL EVENT IN BEDFORD!
Fourteenth Community Fair of Bedford Grange
—————— COMING ——————
WEDNESDAY, SEPTEMBER 24, 1924, 2 P. M.
THIS IS YOUR FAIR

If you have any product of field or fireside, or any livestock of interest to yourself be sure it will interest others. We ask your co-operation as in past years to make this fair better than ever.

Numerous prizes will be awarded. Out of town judges will make decisions.

Livestock Exhibition in rear of Town Hall.

Exhibits should be at Town Hall by 12 o'clock.

Further particulars of the Fair Committee. Prize list to follow.

Mr. John R. Comley, *Chairman*	Mr. and Mrs. A. E. Blake	Mrs. David L. B. Fitch
Mrs. John R. Comley, *Secretary*	Mr. and Mrs. F. S. Lydiard	Mr. Charles W. Jenks
Mr. Louis Pfeiffer, *Treasurer*	Mr. and Mrs. Geo. H. Sweetnam	Mrs. Jennie Temple
Mrs. Louis Pfeiffer	Mr. and Mrs. Wm. Thompson	Mrs. Mary E. Laws
Mr. and Mrs. R. W. Brown	Mrs. Maybelle L. Williams	Mr. Chester G. Barnes
	Mr. Howard D. Skelton	

From the time of its founding in 1909, the Bedford Grange was a center of social life. Meetings featured lectures, entertainments, and rituals leading to conferral of degrees within the organization. The premier event was the annual Grange Fair. Meetings were held in the old town hall on South Road until 1925, when the Bedford Grange purchased the Bedford House hotel. (BHS.)

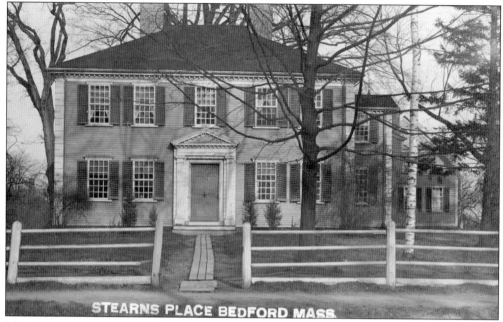

STEARNS PLACE BEDFORD MASS.

This Georgian house at 26 The Great Road was built by architect Reuben Duren in the 1770s or 1780s for Bedford's third minister, Rev. Joseph Penniman. The interior is ornamented with murals attributed to noted artist Rufus Porter. Because Penniman did not accompany Bedford's soldiers to the Battle of Concord, some infer that he was a Tory.

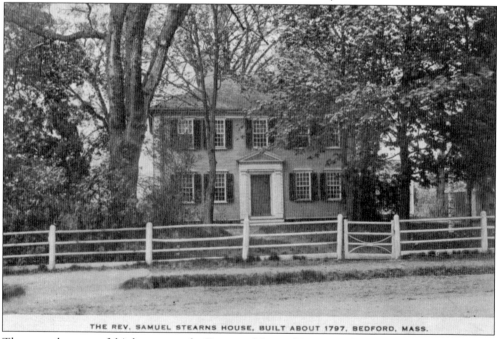

THE REV. SAMUEL STEARNS HOUSE, BUILT ABOUT 1797, BEDFORD, MASS.

The second owner of this house was the Reverend Samuel Stearns, who became Bedford's fourth minister in 1796. He and his wife, Abigail, raised a large family here. Four of their five sons graduated from Harvard College and became ministers. One of the sons, William Augustus Stearns, became president of Amherst College.

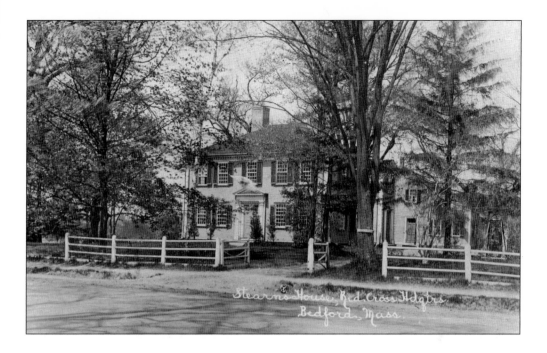

Charles Jenks purchased the Stearns house when he was living next door at Fitch Tavern. He made his new property available for the headquarters of the local Red Cross. His sister Caroline Jenks was the chairman of the work committee, whose volunteers knitted and sewed huge quantities of bandages as well as clothing for soldiers and war refugees in France and Belgium. Six sewing machines were kept in constant use. Half a dozen of the most active workers earned a Red Cross medal for completing more than 3,200 hours of sewing. The group also sent Christmas boxes to the soldiers and raised more than $27,000 to benefit the troops. (Both, BHS.)

BEDFORD RED CROSS COMMITTEE

May 18 - 25 inclusive has been designated by the **President** as **Red Cross** week. Again let us put Bedford **over the top.**

Is there a person who does not know of the wonderful work of the Red Cross and of the suffering, sickness and distress that it is alleviating under whatever conditions? Our boys are crying out to us to support this greatest agency of charity.

In the last drive Bedford raised nearly (ten thousand) dollars, and in this drive let us make the sky the limit.

Saturday, May 25th., solicitors will call at your home. Give generously and exercise the proud privilege to directly help our boys. Give cheerfully, and let your local pride swell the quota of Bedford, as 25% of amount raised will be available for our local Chapter.

All contributions left with Mr. Henry D. Lyons will be forwarded to the committee.

BEDFORD RED CROSS COMMITTEE

Mrs. HENRY D. LYONS, of the Red Cross Chapter, Chairman
Miss MARY PARKER GEORGE R. BLINN, Esq.
HENRY D. LYONS NATHAN H. DANIELS,
 SHERMAN G. RICH

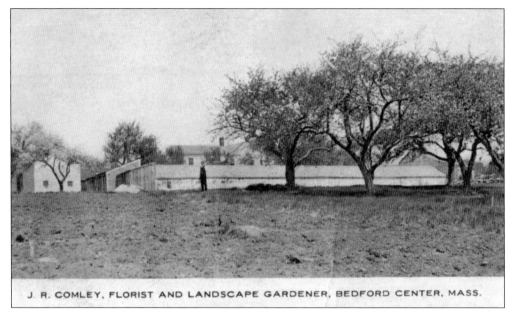

J. R. COMLEY, FLORIST AND LANDSCAPE GARDENER, BEDFORD CENTER, MASS.

John Ridgway Comley was the son of a noted horticulturist from England, James Comley. The younger Comley grew geraniums, sweet peas, violets, chrysanthemums, and other flowers in his greenhouses on Elm Street and sold them at market in Boston. A wood-fired furnace at the back of the greenhouses provided heat. Comley also owned two barns and a few cows and pigs. (BHS.)

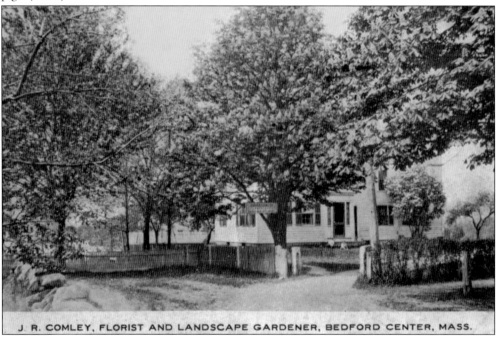

J. R. COMLEY, FLORIST AND LANDSCAPE GARDENER, BEDFORD CENTER, MASS.

In addition to being a nurseryman, John R. Comley was a master of the Bedford Grange, a town selectman, and the superintendent of the Shawsheen Cemetery for 22 years. His house at 49 Elm Street is still standing. Elm Street originally ended in front of the fence seen on the left side of this postcard. (BHS.)

Three

BEYOND THE CENTER

Beyond the village center, a variety of subjects found their way onto postcards. Bedford residents are clearly proud of their historic sites, such as the Two Brothers Rocks, and stately homes, such as Claude Palmer's Fairwick. Civic pride is seen in postcards of the town's water supply system, new in 1909 and marking Bedford as a progressive town.

Postcards also preserve Bedford pastimes, summer cottages on the Concord River, and social organizations, like the Bedford Men's Club. Images of residential streets and winding country lanes, such as Burlington Road and the old Indian Hill Road, have great sentimental value. The entrepreneurial spirit is reflected in postcards of Bedford businesses; for example, the Bedford Safety Razor Company and the Oakland Boat & Canoe Livery.

Postcards also document major changes. The railroad that came in 1873 brought Bedford and Boston closer together. In the 20th century, the town's original business district from the Town Common northwest to Carlisle Road was gradually displaced by a new business zone along the eastern portion of the Great Road.

The house just visible on the far right was 66 South Road, the childhood home of town historian John Dodge. The glass bottle on the walkway belonged to his mother. The white dog is standing at the corner of Crescent Avenue. The house beyond the dog, at 60 South Road, is still standing today.

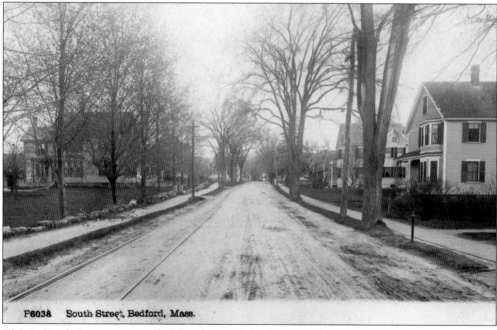

This is South Street, now called South Road, looking northward toward Main Street. Note the trolley tracks on the left. The Lexington & Boston Street Railway opened a branch from Arlington Heights through Lexington, Bedford, and Billerica to Lowell in 1900. The Bedford portion ran along Main Street, down Loomis Street to the railroad station, and up South Road to return to Main Street.

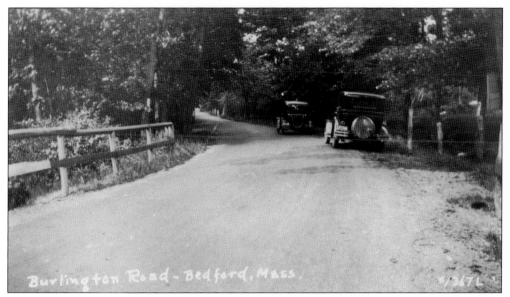

The railings on the left side of Burlington Road most likely overlook the millpond that was created by a dam on the Shawsheen River just off Old Billerica Road. The parked cars belong to people who perhaps have stopped for some fishing. Burlington Road was a narrow country lane that led through forest and past a few scattered farms.

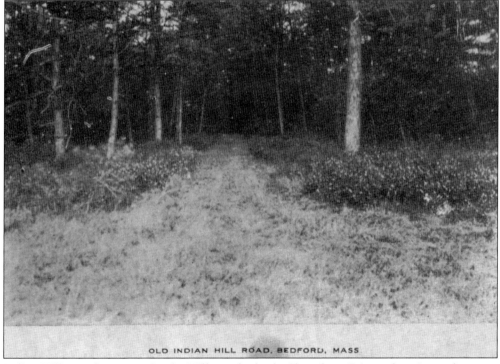

Indian Hill, now known as Crosby Hill, overlooks the Shawsheen River where it runs between Route 3 and the Middlesex Turnpike. In the 1850s, the only road on Indian Hill led to the Crosby farm. That road no longer exists. Today's Crosby Drive runs east of, and roughly parallel to, the old farm road. (BHS.)

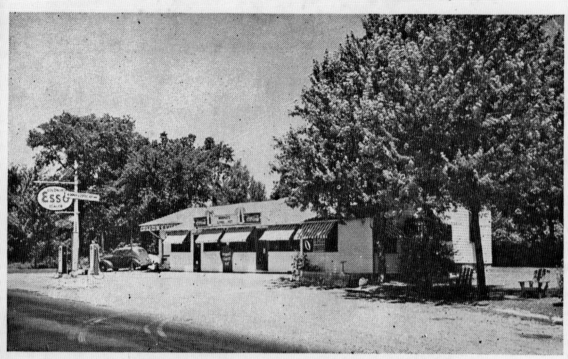

MURPHY'S COFFEE POT - - BEDFORD, MASS.

Murphy's Coffee Shop and Esso station stood at 379 North Road. The gas pumps were still there in 1968, when Homer Zwicker moved his skate sharpening service here from Arlington. The business prospered so well that the building has been enlarged twice. H.A. Zwicker, Inc., is still operating in this building.

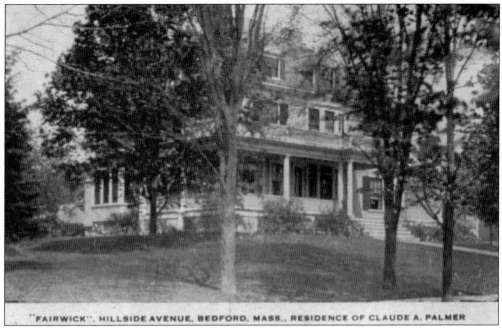

Fairwick, a Colonial Revival mansion still standing at 34 Hillside Avenue, was built in 1888 for Arthur W. Blake, proprietor of a men's clothing store in Boston. In 1918, it became the property of Grace and Claude A. Palmer. Claude served as a Bedford selectman and as the town moderator. The carriage house remains, but a greenhouse that once stood on the property is gone. (BHS.)

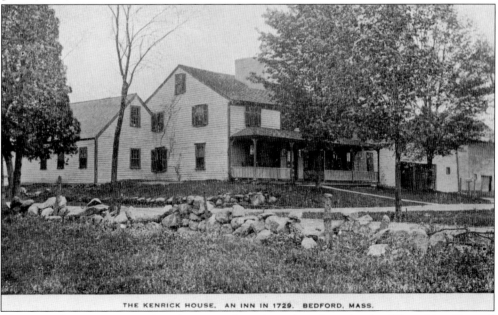

The Kenrick House at 137 Shawsheen Road was long thought to be the "Shawshine House," known to be a trading post in 1642, but this is now considered unlikely. Benjamin Danforth ran a tavern here at the time of Bedford's founding. Stripped of its barn, back house, and porch, the home otherwise looks much the same today.

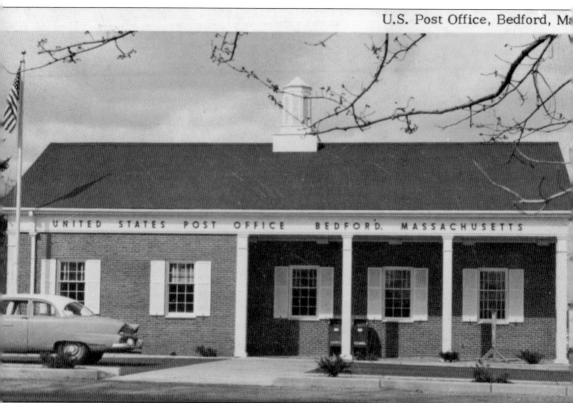

Bedford's post office has wandered. It began in a building at 4 The Great Road. Later, it moved to the Mudge dry goods store across the street, then to the Fletcher Block, and then to the block of stores at the corner of South Road and the Great Road. The post office then relocated to the building shown here. It finally moved to 168 The Great Road. (BHS.)

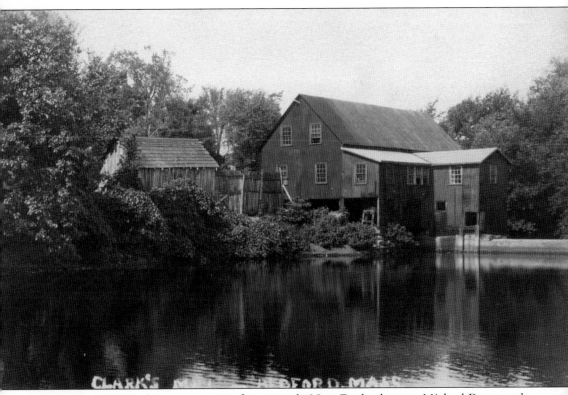

A mill to grind grain being a necessity for any early New England town, Michael Bacon and Timothy Brooks built a mill at this site on the Shawsheen River in the 1660s. A later mill on the same site was owned by three generations of the Fitch family, then by William Ashby. Charles Clark bought the mill, by then a sawmill, in 1874. After it burned down, he replaced it with the mill seen here. Herbert Clark inherited it in 1921. In 1945, the Town of Bedford bought the property and destroyed the dam. In 1763, the mill at this location was the scene of a dastardly crime. Miriam Fitch, the miller's wife, also known as the "Witch of the Shawsheen," collected money from two Boston men, lured them to the mill with the promise of buried treasure, and locked them in a hole that was soon to be flooded. They escaped with their lives, and Fitch was given a jail sentence. (BHS.)

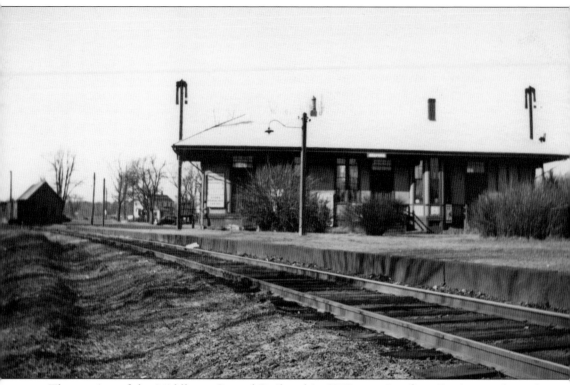

The coming of the Middlesex Central Railroad in 1873, running from Lexington through Bedford to Concord Center, brought many changes to Bedford. Manufacturing and freight-shipping businesses sprang up around the depot. One of the earliest factories was the Bedford Wood Rim Company. In 1891 came the Bedford Lumber & Manufacturing Company, a major employer. Smaller factories were developed as well. Freight businesses included Charles C. Corey's elevator and storehouse for grain, feed, and cement and other building supplies. The Hodgdon brothers moved their livery stable from Main Street to the depot area. In 1877, the Billerica & Bedford narrow-gauge railroad line began to run between the Bedford depot and Billerica. The Bedford depot was moved across South Road to its current location, close to the junction of the two railroad lines. During this period, housing began to be built along the section of South Road near the depot, and Webber Avenue began to be developed. Bedford started becoming, in a small way, suburban.

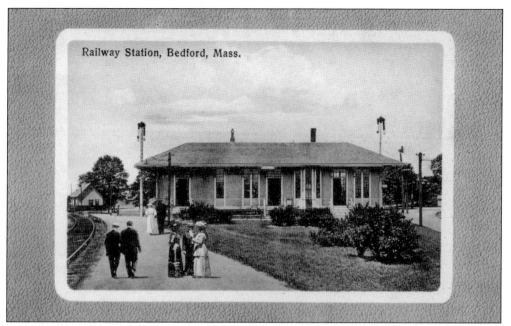

Railway Station, Bedford, Mass.

In a 1906 article about the annual "Station Beautiful" contest run by the Boston & Maine Railroad, the *Boston Daily Globe* said that the "Bedford, Mass. Station . . . has for twelve consecutive years been awarded from sixth to second-class prizes. . . . The enterprising agent has this summer created a display that has won him many compliments . . . in that pretty and progressive town."

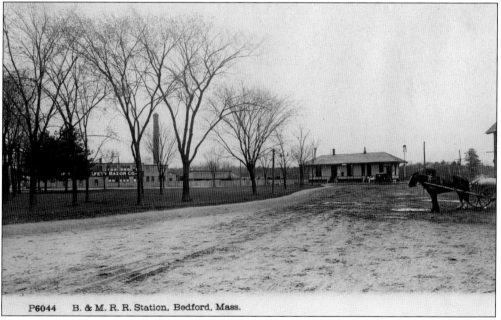

P6044 B. & M. R. R. Station, Bedford, Mass.

This view down Railroad Avenue looks toward the railroad station. Behind the trees on the left is the Bedford Safety Razor Company. Immanuel Pfeiffer Jr. incorporated the business in 1913 and, for a few years, manufactured the first swivel-headed razor here. After the company failed, he became the proprietor of the Arabian Manufacturing Company at or near the same location.

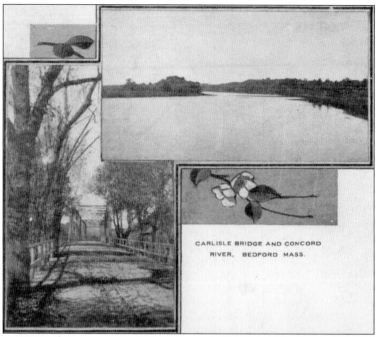

CARLISLE BRIDGE AND CONCORD
RIVER, BEDFORD MASS.

The old Carlisle Bridge, built in 1903, was made of steel and paved with wooden planks. Cars going over it made a clatter that could sometimes be heard at the opposite end of town. The current Carlisle Bridge, built in the 1950s, is a little upstream from the old bridge, and Carlisle Road was rerouted to meet it. The old road now leads to the town boat landing.

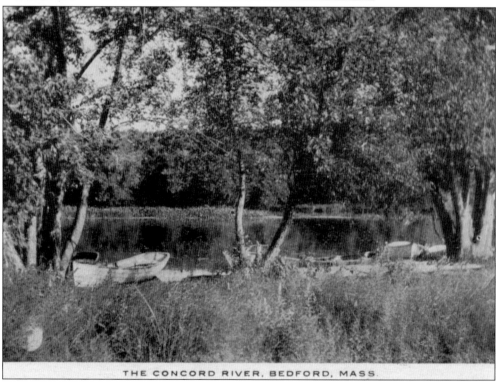

THE CONCORD RIVER, BEDFORD, MASS.

Though the Concord River has a substantial flow, in Bedford, its broad floodplain made it unsuitable as a site for water-powered factories. This prevented Bedford from becoming another of the many New England mill towns. Instead, the Concord has been primarily a site for recreational uses, such as fishing and boating. (RA.)

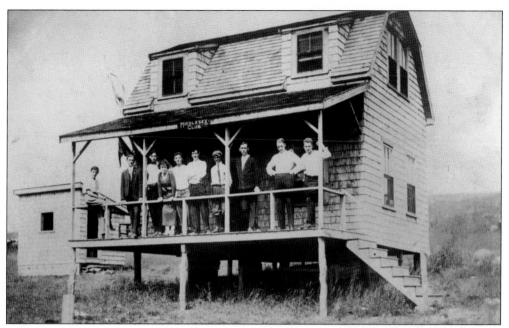

This gambrel-roofed cabin is typical of a group of buildings constructed as summer cottages or "camps" near the Concord River in west Bedford. A signboard over the porch identifies this one as the Middlesex Club. A number of the surviving cottages have been converted to year-round houses. They can be seen on Rand Place, Riverside Avenue, Bonair Avenue, and the adjoining section of Davis Road. (JG.)

Edwin N. Rand rented out rowboats and canoes at his Oakland Boat and Canoe Livery on the Concord River in west Bedford. The streetcars that ran along Concord Road brought customers, dropping them off at the end of Davis Road. The boathouse, which stood near the end of today's Rand Place, burned down in September 1921.

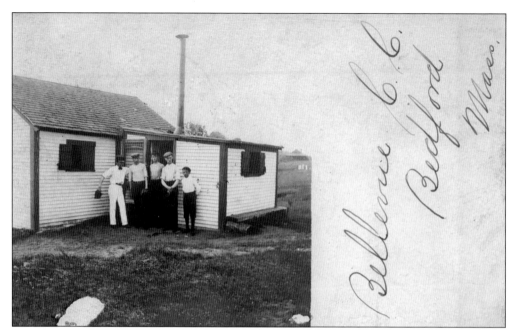

Little is known about the Bellevue Camping Club on the Concord River. In the postcard above, the man on the far left is wearing what might be a milkman's uniform and is holding a camera. The man next to him holds a catcher's mitt. In the postcard below, a signboard under the gable window reads, "Bellevue Camping Club." In the early decades of the 20th century, many small summer cottages were built near the Concord River. Because this one was called a club and appears on two postcards, it might have been a commercial operation hoping to attract guests. Summer cottages along the river near Davis Road were fairly close to the streetcar line that ran down Concord Road, making them accessible to out-of-towners.

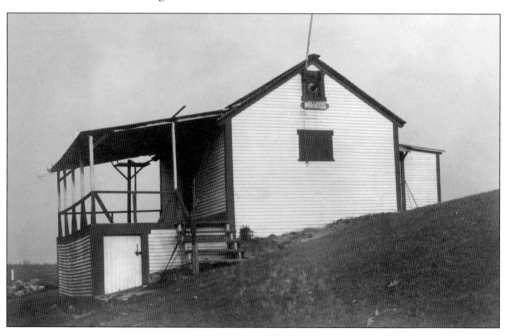

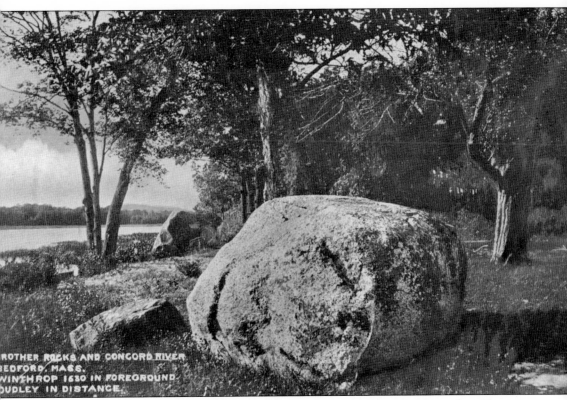

BROTHER ROCKS AND CONCORD RIVER
BEDFORD, MASS.
WINTHROP 1630 IN FOREGROUND
DUDLEY IN DISTANCE.

In 1637, the Massachusetts Bay Colony awarded Gov. John Winthrop and Dep. Gov. Thomas Dudley 1,000 acres of land each along the Concord River. (Winthrop's grant was soon increased to 1,200 acres.) Travelling along the river in 1638, the two men chose what they called the Two Brothers Rocks as the dividing point between their lands. The Winthrop grant occupies a fifth of what is now Bedford, and the Dudley grant lies mostly in Billerica. What was the reason for such a significant award? Winthrop had been governor of the colony from 1629 to 1634. In 1637, he was reelected in the midst of a religious controversy. Anne Hutchinson had been preaching that believers could communicate directly with the Almighty and find salvation without the intervention of the ordained clergy. This was so threatening to the established order that Winthrop put her on trial in November 1637 and had her banished from the colony. In that same month, he and Dudley were granted their lands. (JG.)

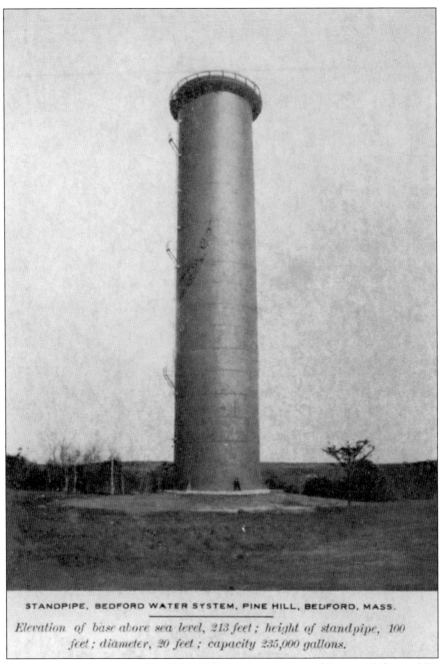

STANDPIPE. BEDFORD WATER SYSTEM. PINE HILL. BEDFORD. MASS.

Elevation of base above sea level, 213 feet; height of standpipe, 100 feet; diameter, 20 feet; capacity 235,000 gallons.

This water tower was constructed in 1908–1909 as a component of the town's first public water supply system. This massive undertaking required a reservoir, a ring well, a water tower to provide water pressure, a pump house, and an extensive system of pipelines to deliver the water. The cost was more than $58,000. Creating the reservoir required construction of an earthen dam to enlarge a small, natural pond in the woods off Shawsheen Road. The standpipe on Pine Hill Road stood 100 feet high on solid masonry foundations seven feet thick, and it served the town for about a century before being demolished. The pump house on Shawsheen Road is still standing. In 2012, work began to replace the century-old dam and to renovate the ring well. (JG.)

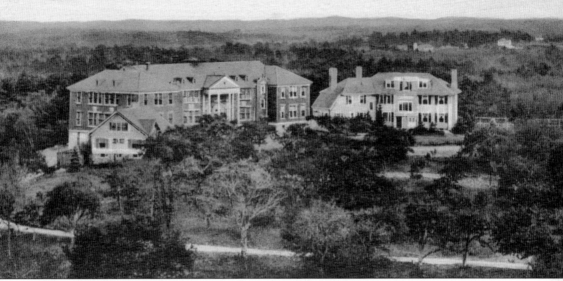

In 1926, the Marist Fathers of the Society of Mary bought the mansion and 200-acre estate of William Everett Macurda and his wife, Georgie A. Macurda, on Springs Road. There, the Marists founded the Maryvale Seminary. Offering four years of high school and two years of college, the seminary prepared young men for further studies leading to the priesthood. The Marist Fathers built the large brick building seen on this postcard to house student dormitories, classrooms, and a chapel. The building on the right was already on the property. The seminary remained in operation until 1969, when declining enrollments led to its closing. In 1972, Middlesex Community College began leasing, and later purchased, the Maryvale property. These two large buildings are now part of the college campus. The small house on the left is no longer there.

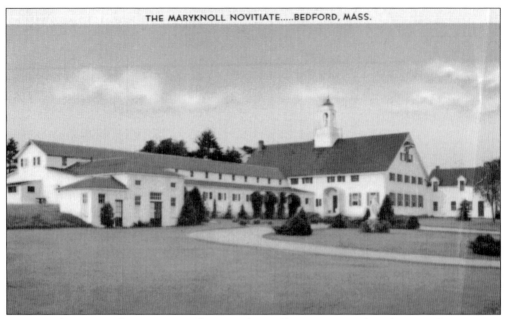

In 1924, the Stearns farm at 77 Dudley Road in Billerica was purchased as an adjunct to St. John's Seminary of Brighton. In 1933, the property was transferred to the Maryknoll Fathers and Brothers, who trained young men to serve as missionaries. They called it their Bedford Novitiate because it had a Bedford mailing address. Novices spent one year here before returning to the Maryknoll seminary in Ossining, New York, for four years of further training. Some of the farm buildings were converted to dormitories, with much of the work being done by the novices. Farming operations were continued in order to provide food for the community. In 1951, the novices built the chapel of Our Lady of the Snows. In 1964, the Maryknoll Novitiate moved away. The property is now used as St. Thecla's Retreat House.

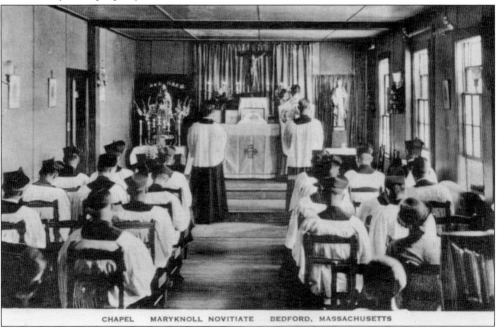

CHAPEL MARYKNOLL NOVITIATE BEDFORD, MASSACHUSETTS

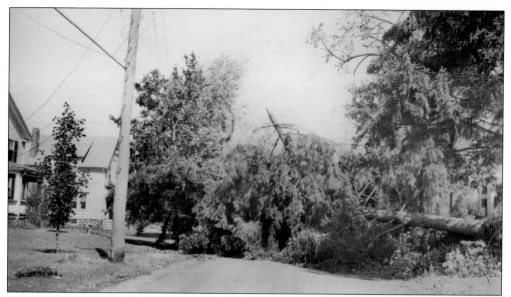

The hurricane of September 21, 1938, caused widespread destruction throughout New England. There was no loss of life in Bedford, but houses were damaged and thousands of trees were felled. The tree shown on this postcard stood in the front yard of Mehta Kourian's house at 34 Springs Road. It fell across Hancock Street. (BHS.)

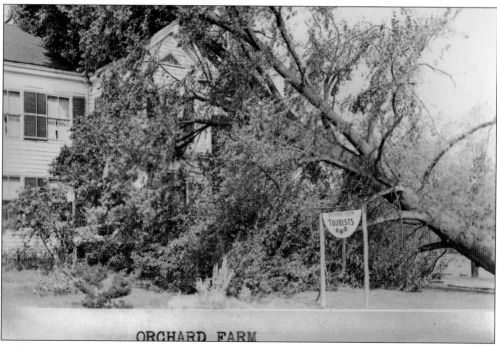

Orchard House, which still stands at 238 The Great Road, was run as a lodging house. A 1919 advertisement said, "Wanted—summer boarders; pleasant location, handy to steam [trains] and electric [trolley] cars. Orchard View Farm." In this photograph, a tree downed by the Hurricane of 1938 temporarily obscures the house, but the signboard can still be seen. (BHS.)

Shady Hill Nursery was founded in 1880 as part of Geneva Nursery in Geneva, New York. Advertisements from the 1890s state that the company had a business office in Boston and 200 acres of land in Bedford. Buyers from the city could travel to the Shady Hill Station, a railroad stop near today's Hartwell Road, to view the nursery stock. In 1912, John Kirkegaard (the father of future town historian Louise K. Brown) bought the Shady Hill Nursery Company, where he had long been an employee, and renamed it New England Nurseries. When not running the business, Kirkegaard found time to write a book on horticulture; serve Bedford as a selectman and a member of the school committee, finance committee, and water commission; serve as president of several industry groups; and participate in various social organizations. He died in 1932. New England Nurseries, now a smaller operation, still belongs to the Brown family.

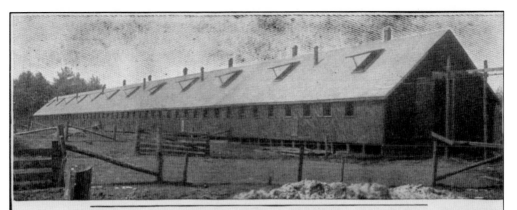

Dr. Sidney B. Elliot, the medical director of the Willard Hospital on Old Billerica Road, bought an adjoining farm near the junction of Burlington Road in 1904. Calling it Belle Meade Farm, he bred and sold Shetland ponies. Hospital patients were encouraged to help out at the farm. Onlookers dropped by daily to watch the herd of ponies. Elliot's 1906 book, *The Shetland Pony: His Breeding, Care and Training*, featured many photographs of Belle Meade. He states that pony breeding helped him unwind from the cares of running a hospital for "cases of a nervous character." He also raised pigs. In 1905, Elliot sparked a controversy when he applied for permission to transport garbage from Boston hotels to the 800 animals in his Bedford piggery. At a public hearing, both Judge Elihu Loomis and a representative of Lexington Park objected strongly to the plan. Dr. Elliot died in 1909.

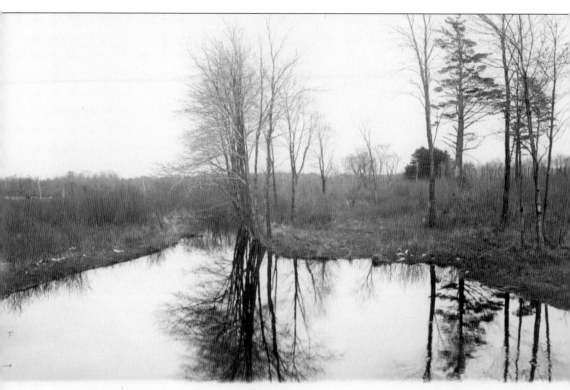

P6043 Elm Brook, Bedford, Mass.

Although this scene looks gloomy, in summertime, this pond was a good swimming hole. It was a wide section of Elm Brook, where it met Shady Hill Lane, a cart road off Concord Road that ran approximately where the northern part of Hartwell Road is today. The land all around was open farm fields. The road crossed the brook over a simple bridge of rough planks. Town historian John F. Brown has written that, when he and his friends were boys in the 1930s, they enjoyed using this pool as a clothing-optional beach, despite the numerous leeches. Louise K. Brown has said that the part of Shady Hill Lane that ran through the New England Nurseries property was beautifully groomed by the landscape department, and the men took great pride in its appearance. In the fields on the west side were perennials and greenhouses; in the fields on the east were ornamental shrubs. (JG.)

Bedford Men's Club

Bedford, Mass.

Just a reminder—don't forget the meeting of the Bedford Men's Club, Friday evening, December 19th, at the Civic Club House, Loomis St. We desire a large attendance.

Yours truly,

S. G. WHITTAKER, President

. W. RAYMOND, Secretary

The Bedford Men's Club was founded in 1921 to provide "a perfect excuse for good fellowship once a month" and, more seriously, to perform community service and promote better relations among men in the community. The club does not seem to have survived beyond the 1930s. The location mentioned in this postcard, the Civic Club House, stood at 51 Loomis Street. The Bedford Civic Club, another organization focusing on service and fellowship, was in operation from 1907 until the 1950s. Meetings often featured speakers on topics of interest to the community; for example, a 1956 talk on zoning laws. In 1926, the Civic Club took a strong stand when the Boston & Maine Railroad proposed discontinuing service to Bedford. The club also sponsored community events such as children's Christmas parties, Christmas carols on the Town Common, and field day games. The Civic Club was long remembered for the massive bonfires it lighted each Fourth of July. The Civic Club House has since been demolished. (BHS.)

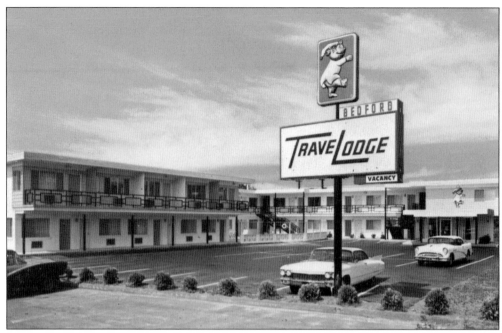

Built in 1963, the Bedford Travelodge—originally billed as the Travelodge Modge—was an adjunct to the Great Road Shopping Center. That same year, and just a few doors down the street, the Elm Brook Motor Inn was being built. Bedford was poised for growth, with some $8.5 million in industrial, business, and school construction planned for 1963. The 44-unit Travelodge (above) cost a quarter of a million dollars. The 104-room Elm Brook Motor Inn (below) cost $800,000. Built on a triangular plot of land at 340 The Great Road, this motel later came to be known as the Arrowhead Inn. Today, it is the Bedford Plaza Hotel. The courtyard was originally open to the sky but has since been roofed over. The Travelodge was demolished in 2013.

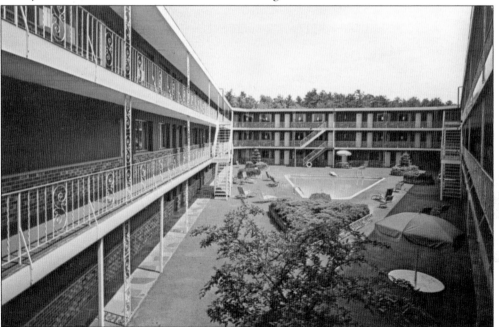

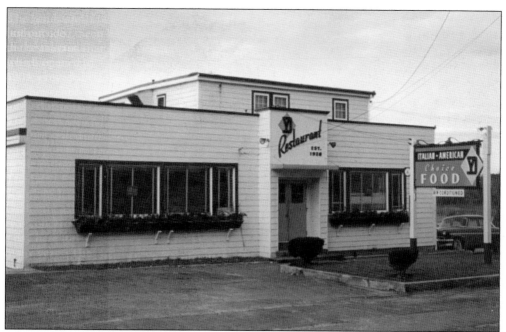

The YD Restaurant, established in 1926, stood on the Great Road near the intersection of Pine Street, close to the YD Poultry Farm. In 1958, the YD Restaurant was succeeded by the Toy Sun Restaurant, whose proprietor, Clarence Lew, offered both Italian American and Cantonese foods. The restaurant is gone, but YD Road still runs behind the site.

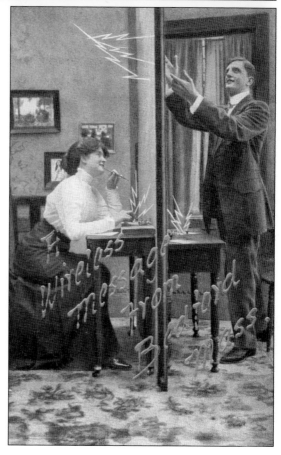

This postcard depicts a woman in Bedford sending a message to her faraway lover through the miracle of the telegraph. It really has nothing to do with Bedford, but its charm is undeniable. The scene seems to anticipate a world in which telegraphs in private homes would make instant communication possible. Evidently, the telephone's ability to achieve the same ends was not foreseen.

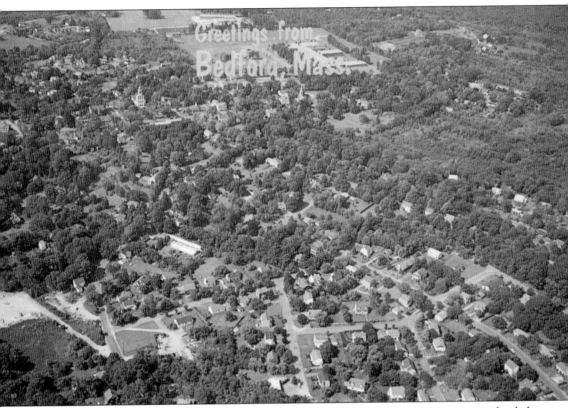

In this 1966 aerial view, the steeple of the Unitarian church on the Town Common can clearly be seen on the upper left. It faces the Great Road, which runs horizontally. The message "Greetings from Bedford, Mass." lies over the high school and its playing fields. The John Glenn School is above the word "Greetings." Town hall is under the first letter "d," and the Congregational church is under the letter "M." Following the Great Road to the left, the large pillars of the Jonathan Bacon house at 133 The Great Road can be seen near the left edge of the postcard. In the lower left quadrant are the greenhouses of Oxbow Gardens at 56 Springs Road. The large open area near the left edge adjoins the former railroad line. The road leading to the lower right corner is Hancock Street.

Four

BEDFORD SPRINGS

Mineral–laden springs in the northern part of Bedford led to the development of the area as a health resort in the 1800s. Legend has it that Native Americans attributed medicinal powers to the waters that sprang from the ground, and later settlers became convinced of their curative properties. In 1843, the Springs Hotel was built at Bedford Springs to accommodate the visitors who came for the mineral waters. In 1866, the property was purchased by the New York Pharmaceutical Company, whose president was Dr. William Richardson Hayden. In 1868, he bought the pharmaceutical company and brought it to Bedford, where he ran both the pharmaceutical business and the Springs Hotel.

Under Dr. Hayden's management, the New York Pharmaceutical Company manufactured dozens of patent medicines. Between the two businesses, pharmaceuticals and the hotel, he was very successful. By 1891, he had built two new pharmaceutical buildings and a mansion called Lakeside for his family. In 1897, he replaced the old Springs Hotel with the grand, new Sweetwater Hotel. Wealthy guests from Boston and elsewhere came to stay at the hotel, take the waters for their health, and relax in luxurious surroundings.

Dr. Hayden was a self-made man. Born to Irish immigrants in Salem in 1820, he had lost his father when he was still in his teens and had to make his own way. A brief career in theater was followed by medical school. While in medical practice in New York, he began inventing patent medicines and was eventually hired by the New York Pharmaceutical Company. In Bedford, in addition to manufacturing an extensive catalog of patent medicines and running the hotel, he wrote his own marketing materials, ran his own farm, maintained a private medical practice in Boston and Bedford, served as the Bedford Springs postmaster, and served on Bedford's board of selectmen and school committee. In 1916, his widow presented to the town the memorial fountain that still stands at Springs Road and the Great Road.

For many visitors, the first view of the Bedford Springs resort would have been its railroad station. Dr. Hayden had helped bring the first railroad as far as Bedford Center in 1873, and the narrow-gauge Billerica & Bedford Railroad, which stopped at Bedford Springs, in 1877. After the narrow-gauge line failed, the route was converted to standard gauge. In 1898, the fare from Boston to Bedford Springs was 36¢.

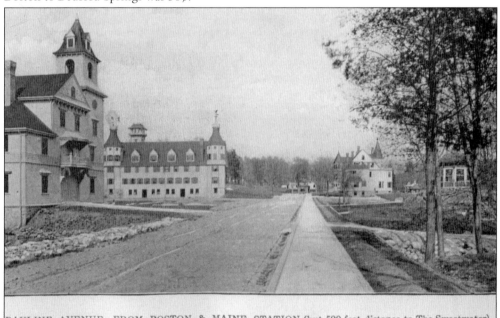

PAULINE AVENUE, FROM BOSTON & MAINE STATION (but 500 feet distance to The Sweetwater) BEDFORD SPRINGS MASS.

After stepping off the train, the visitor would have seen Pauline Avenue—Dr. Hayden had a daughter called Pauline. The road is today called Sweetwater Avenue. The building on the left is evidently the one still standing at 94 Sweetwater Avenue, although it now has only two stories, and the tower is shorter. The building just beyond it, an 1892 pharmaceutical factory, has been converted to condominiums.

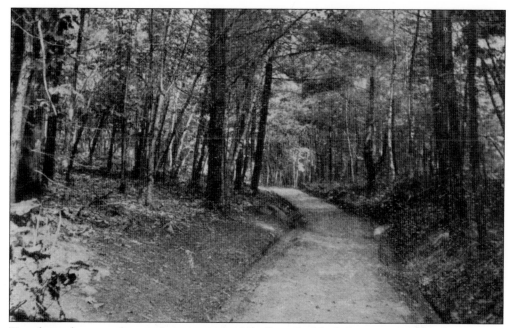

Travelers who came by carriage or automobile from Bedford Center arrived at the hotel by way of Springs Road. A promotional piece about Bedford Springs, laden with flowery prose, describes "Dew Vale" as a romantic spot on the route to Fawn Lake. Springs Road is now much wider than this one-lane track through the woods. (RA.)

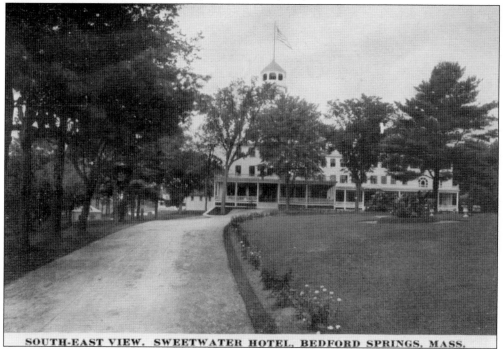

SOUTH-EAST VIEW. SWEETWATER HOTEL, BEDFORD SPRINGS, MASS.

When travelling by road from Bedford Center, a visitor, having just passed Fawn Lake, would enter a driveway and be greeted with this view of the Sweetwater Hotel, with a flag waving from its tower. Remnants of this driveway can still be found in the woods along Springs Road.

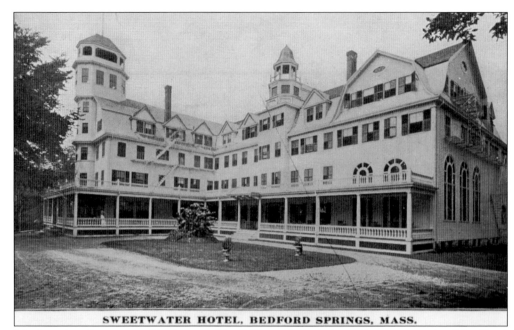

SWEETWATER HOTEL, BEDFORD SPRINGS, MASS.

The luxurious Sweetwater Hotel, opened in 1897, was "of strictly modern construction." It offered 64 guest rooms plus dining rooms, parlors, smoking rooms, music rooms, steam heat, electric lights, a "commodious elevator," telephone and telegraph services, and "perfect sanitation, the best system of open plumbing that money can buy." The hotel was open from May to October.

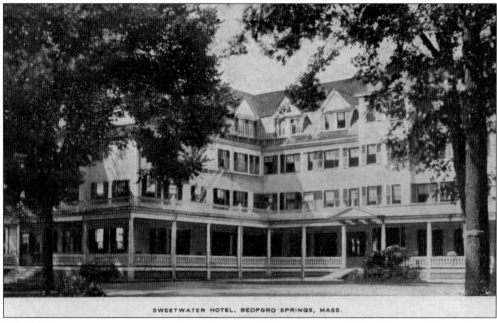

SWEETWATER HOTEL, BEDFORD SPRINGS, MASS.

All of this luxury came at a price. A brochure listed the Sweetwater Hotel's rates: "Board by the day, $3.00 to $5.00. Board by the week, $15.00 to 25.00." This seems to have been acceptable to many people who wished to escape the summertime heat of Boston. The combination of recreational activities, pure country air, and medicinal waters was a powerful inducement to spend the whole summer here.

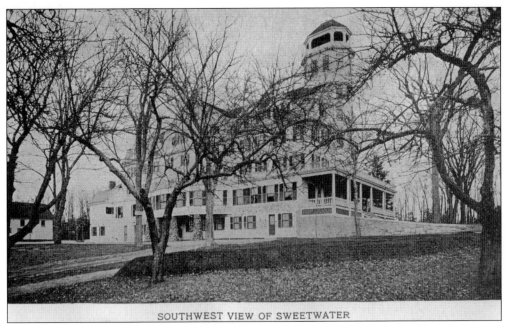

SOUTHWEST VIEW OF SWEETWATER

Here, the Sweetwater Hotel is seen through an apple orchard. The hotel had an observation tower, a product of Dr. Hayden's fanciful taste in architecture. All of his major buildings—the Sweetwater, the two pharmaceutical buildings, his mansion—had towers. There was also a freestanding observation tower that doubled as a water tower.

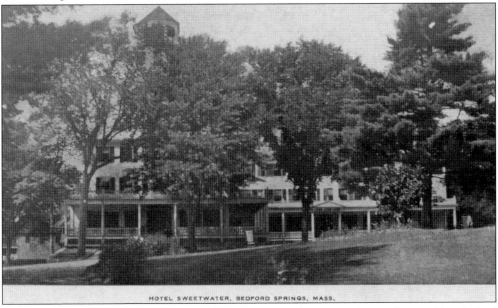

HOTEL SWEETWATER, BEDFORD SPRINGS, MASS.

The luxurious Sweetwater and its wealthy guests proved a temptation to those with criminal intentions. On September 5, 1905, burglars took $2,000 worth of jewelry, plus stock certificates and other papers belonging to summer guest Mrs. Charles S. Butler of Newbury Street, Boston. According to the *Boston Daily Globe*, "The robbers apparently came and went in a two-horse vehicle, as the marks of the animals' hoofs, which were muffled with bagging, were plain for some distance."

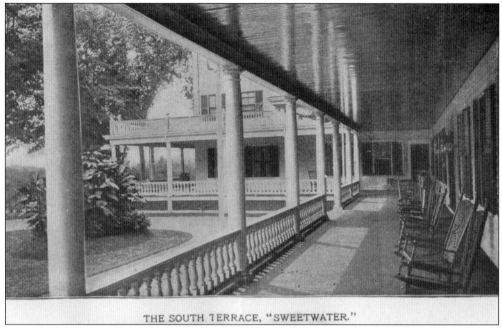

THE SOUTH TERRACE, "SWEETWATER."

Seated in rocking chairs along the veranda, the Sweetwater Hotel's guests could view a formal garden and watch new arrivals coming up the drive. Statuary enhanced the charm of the plantings along the carriageways on the property. Those who did not bring a carriage could rent one for drives to nearby historic sites and for country getaways.

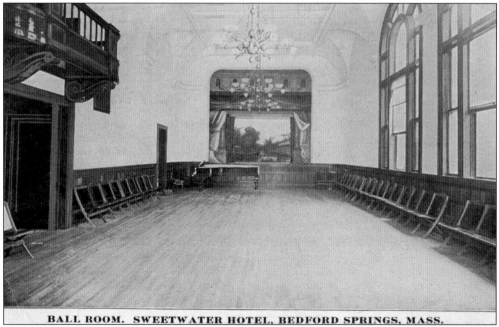

BALL ROOM. SWEETWATER HOTEL, BEDFORD SPRINGS, MASS.

The resort offered both outdoor and indoor amusements. An 1897 marketing booklet called the stage seen here a "Vaudeville Saloon" and stated, "Exquisite music will be rendered by the Sweetwater Orchestra. Daily concerts in the music room and nightly dancing in the ball room." The stage was also available to guests for their own "impromptu entertainments."

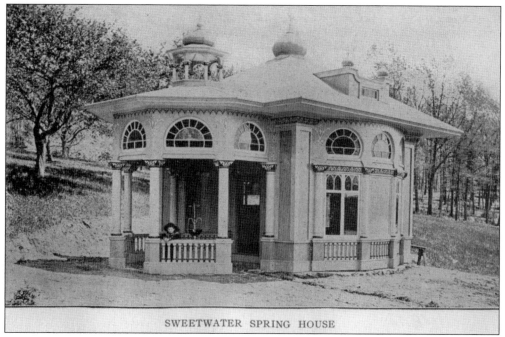

SWEETWATER SPRING HOUSE

This is the second edition of the Sweetwater Spring house. Dr. Hayden's marketing materials promised great things for those who drank the water: "one of the purest and most beautiful waters on the continent. . . . It is nature's remedy, and the best solvent for eliminating and removing calculi, uric acid, and other deposits . . . relieving congestion and reducing inflammatory conditions . . . a remarkable healing and tonic influence . . . especially so in diabetes . . . and Bright's disease."

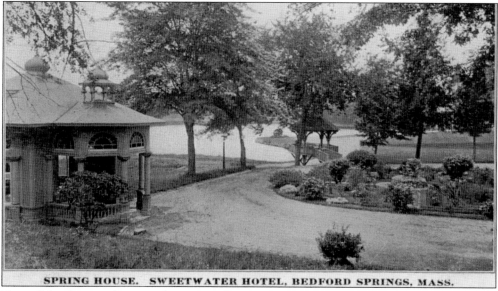

SPRING HOUSE. SWEETWATER HOTEL, BEDFORD SPRINGS, MASS.

Two of the three springwater houses can be seen here. On the left is the Sweetwater Spring house. In the center is a glimpse of the Iron Spring house through the trees. There was also a Sulphur Spring house at the end of Pauline Avenue. Although Bedford Springs was renowned for its supposedly medicinal springwaters, the springs are nowhere in evidence today.

THE ROCKS, BEDFORD SPRINGS, MASS.

This is a rare image of Dr. Hayden, looking out from the original Sweetwater Spring house. When a more ornate version was built, this one was moved from the spring to a pile of rocks overlooking Fawn Lake. The spring house is gone, but the rock pile still stands beside Sweetwater Avenue just past the public parking lot.

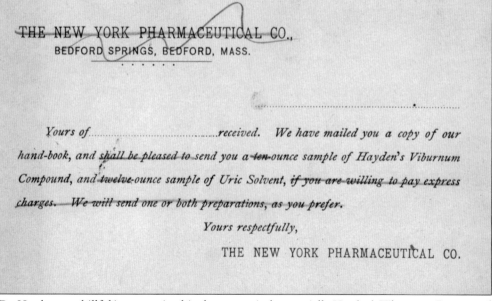

Dr. Hayden was skillful in promoting his pharmaceuticals, especially Hayden's Viburnum Compound and his Uric Solvent. He gathered hundreds of testimonials from physicians who used his patent medicines and published these in his handbooks and catalogs. Hayden's Viburnum Compound was still available for sale in the 1960s, decades after Hayden's death in 1903. (RA.)

74

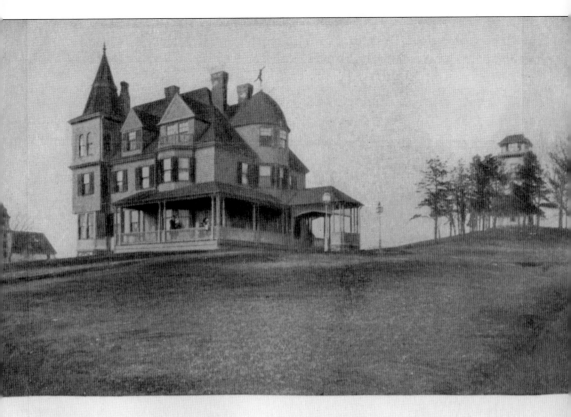

"LAKESIDE," THE RESIDENCE OF DR. HAYDEN, BEDFORD SPRINGS, MASS.

Lakeside, the home of Dr. Hayden and his family, was built around 1890. The mansion stood on a slope overlooking Fawn Lake. To the right of the mansion in this postcard is the combination observatory and water tower. Twice widowed, Dr. Hayden married his third wife, Sarah Holden Everett, when he was over 60 years of age. He and Sarah had five children. Their youngest son, Arthur, eventually took over the pharmaceutical business after the death of his father. Arthur lived nearby in a house, still standing, at 1 Fawn Circle. Sarah died in 1933, and Lakeside was demolished later that year. Sometime afterward, part of Lakeside's foundation was turned into a swimming pool for Arthur Hayden's family. The pool was later filled in with earth, but the upper edges of the foundation walls can still be seen.

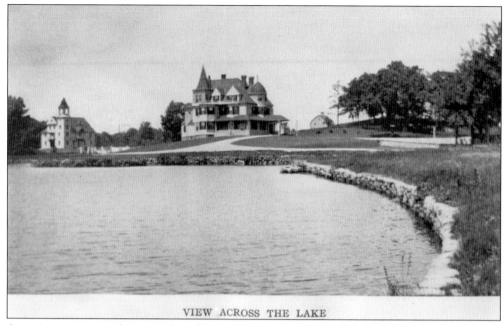

VIEW ACROSS THE LAKE

A carriageway around Fawn Lake offered pleasant rides for the hotel guests, who could bring their own equipage or rent a carriage, complete with horses and attendants, from the livery stable at the hotel. Note the stone wall that borders the lake. Most of the stones were carried away after the property passed out of private hands.

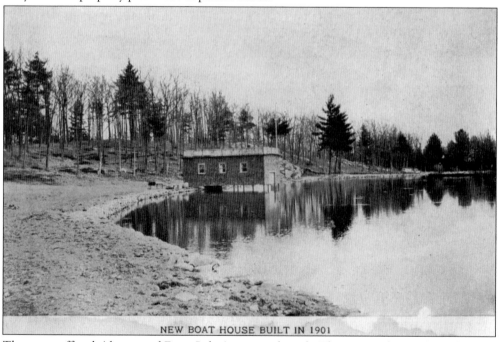

NEW BOAT HOUSE BUILT IN 1901

The resort offered rides around Fawn Lake in a steam launch. There were also rowboats for rent. This 1901 boathouse is probably the last building that Dr. Hayden constructed before his death in 1903. It was located toward the eastern end of the lake, near the rock outcropping that is still a prominent feature of the property.

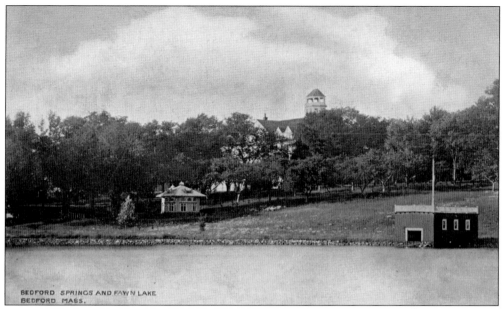

During the years when Bedford Springs was a resort, Fawn Lake was described as the largest artificial lake in New England. A small natural pond had been enlarged by the addition of a small dam close to Springs Road. In recent decades, the lake has been choked by water lilies. Dr. Hayden sold a product called White Lily Lotion. Did he plant the troublesome lilies to make his lotion?

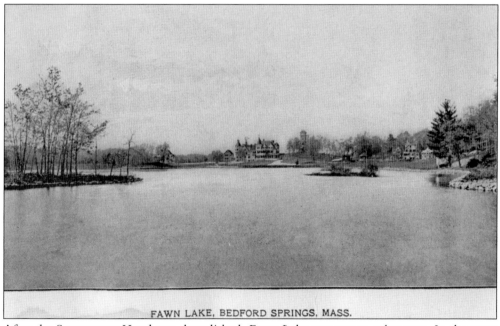

After the Sweetwater Hotel was demolished, Fawn Lake was put to other uses. In the years 1928–1935, the Bedford Athletic Club, as well as other local clubs and high school teams, held hockey matches on the lake. A 1933 game between Bedford and the Belmont Athletic Association, held when the lake was not fully frozen, had to be suspended after all available pucks shot off the ice and into open water.

POST CARD

THIS SPACE FOR CORRESPONDENCE THIS SPACE FOR ADDRESS ONLY

SOMERVILLE WOMAN'S CLUB

OUTING

𝔍une 10, at 𝔅edford 𝔖prings

𝔖weetwater 𝔥otel

Trains leave North Station at frequent intervals. Electric cars leave Arlington Heights every half hour. Luncheon 1 P.M. Tickets, $1.25, may be obtained from Mrs. Maud J. Munroe and Hospitality Committee.

Bedford Springs was a delightful destination for a day trip. Many businesses and social organizations held their annual outings at the resort. Baseball, tennis, golf on a nine-hole course, and other sports could be followed up with a banquet in the hotel. The "electric cars" mentioned here are the trolley cars that ran from Bedford to Lowell along North Road beginning in 1900.

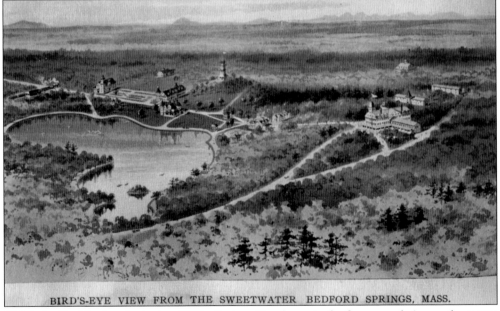

BIRD'S-EYE VIEW FROM THE SWEETWATER BEDFORD SPRINGS, MASS.

This is Bedford Springs in the late 1890s. Springs Road runs in the foreground. Across the center of the image can be seen, from left to right, the following features: a train; the two pharmaceutical buildings with gardens between them and a barn behind; Hayden's home, Lakeside; an observation and water tower; the little spring houses; two unidentified houses; the Sweetwater Hotel; and three unidentified buildings behind the hotel. A steam launch runs on the lake.

Five

THE WILLARD
INSTITUTIONS

Three institutions in succession, all bearing the name of Frances E. Willard, have occupied the same property on Old Billerica Road.

The first was the Willard Hospital, opened on September 26, 1900, for the treatment of "dipsomania" (alcoholism) and "narcomania" (addiction to narcotics) along the most modern lines. Country air, quiet, outdoor exercise, and expert medical supervision were to effect a cure. Though successful for a time, the hospital did not survive the 1909 death of its medical director, Dr. Sidney B. Elliot.

The second institution was Llewsac Lodge, founded in 1910 as a rest home belonging to the Frances E. Willard Settlement in Boston. Caroline Caswell, the settlement's founder, saw a need to aid middle-aged women who needed a temporary home in which to recuperate, learn a job skill, or just recharge their batteries. Llewsac Lodge also became a vacation destination for young working women.

The third institution is Carleton-Willard Village, formed when Llewsac Lodge's parent organization, the Willard Settlement, merged with the Elizabeth Carleton House to create a retirement community for both men and women. Today, Carleton-Willard Village is thriving.

"For God and Home and Native Land."

"Only the Golden Rule of God can bring the Golden Age of Man."

—FRANCES E. WILLARD.

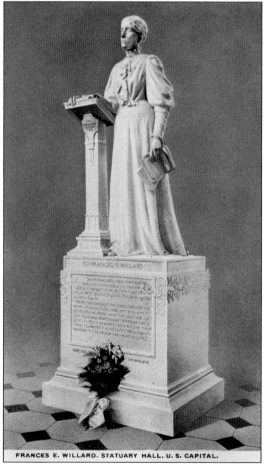

FRANCES E. WILLARD. STATUARY HALL. U. S. CAPITAL.

Although she is not known to have visited Bedford, Frances E. Willard inspired three successive institutions on Old Billerica Road. The Willard Hospital (1900–1909) was named for her. As patients said in their magazine, the *New Leaf*, "Its name is in memory of that great temperance and reform worker, Frances Willard, whose cherished ideas are embodied in the institution." In 1910, the Willard Hospital was succeeded by Llewsac Lodge, a branch of the Frances E. Willard Settlement. Caroline Caswell was moved to create the settlement after hearing a speech by Willard. Llewsac Lodge became today's Carleton-Willard Village in 1982, when the Willard settlement merged with a similar institution. Frances Willard was such a revered figure that, in 1905, her statue (left) was placed in the US Capitol. She was the first woman so honored.

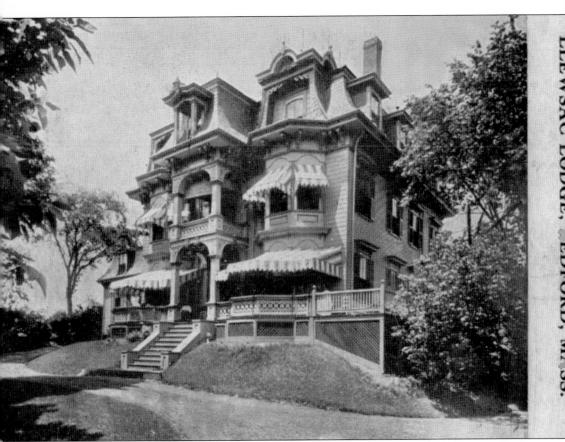

The Willard Hospital was established in this mansion in 1900. As described by the *Boston Evening Transcript*, "The house was built twenty years ago but has never been occupied since that time except by care-takers. . . . [It] is a fine mansion of thirty rooms. . . . Surrounding the house are nearly two hundred acres of fertile fields and woodlands. . . . Exclusion afforded by the hospital, its delightful surroundings, with the excellent care and treatment given, make this a most desirable place in which the patient may regain his health." Another reason for establishing the hospital in Bedford might have been that it was a dry town. The sale of alcoholic beverages had been banned since 1888. The patients were not restrained in any way, but they would have had to travel some distance to get into trouble. In 1904, the hospital acquired an adjoining farm, allowing the patients to get healthful exercise by doing farm chores.

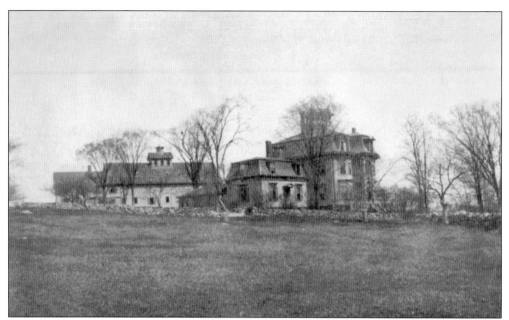

In 1910, after the Willard Hospital closed, the property was acquired by Llewsac Lodge to serve as a temporary home for middle-aged women in need of rest and as a vacation spot for young working women from Boston. The buildings in this photograph stood on the grounds at the time of purchase by Llewsac Lodge. Shown here are, from left to right, Harvey Cottage, the barn, a utility building, and the mansion with a wing on its left side.

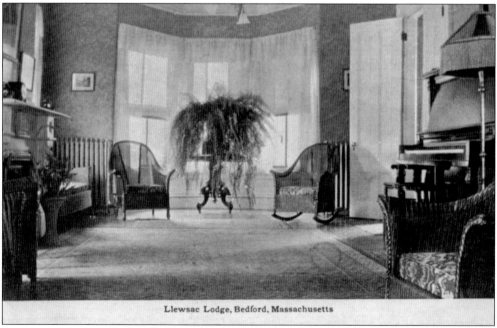

Llewsac Lodge, Bedford, Massachusetts

This room in Llewsac Lodge—the name was applied both to the mansion itself and to the institution as a whole—features wicker chairs, a piano, houseplants, and a carpet, as might be found in any well-appointed private home. The residents were "Protestant women of refinement" between 40 and 60 years old.

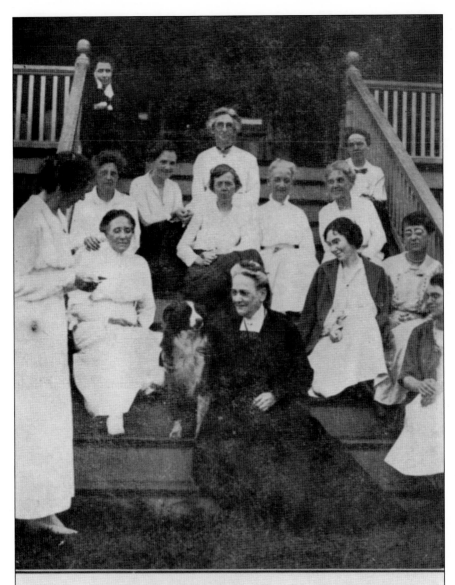

MRS. HIGGINS WELCOMES A NEW MEMBER
OF THE FAMILY.

Myra Louise Higgins was a personal friend of Caroline Caswell and the resident matron of Llewsac Lodge from 1910 until her retirement in 1920. Her task was to make Llewsac Lodge a true home, to give advice and encouragement to the residents, and to oversee their return to health and strength. She received each new resident, arranged work if the woman needed it, and determined how long she could stay. The residents were women who, though not in need of medical treatment, were perhaps tired, discouraged, in need of job training, or in need of some tender loving care. Myra Higgins saw that they got what they needed in order to return to active life. After Higgins left Llewsac Lodge in 1920, the mansion was renamed Myra Louise Higgins House in her honor. She later came out of retirement to take charge of a new Willard Settlement institution, the Ann Judson Ross Home in Northboro, Massachusetts. (CWV.)

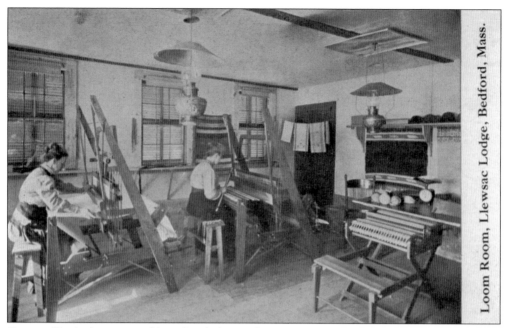

Loom Room, Llewsac Lodge, Bedford, Mass.

Guests of limited means could work to help pay their way. Llewsac Industries, a sideline business, employed women in weaving, needlework, basketry, and food preservation. The products were sold in a gift shop on the grounds, at the annual Open House each spring, at special events in the Boston area, and in stores that wished to aid Llewsac and the Willard Settlement.

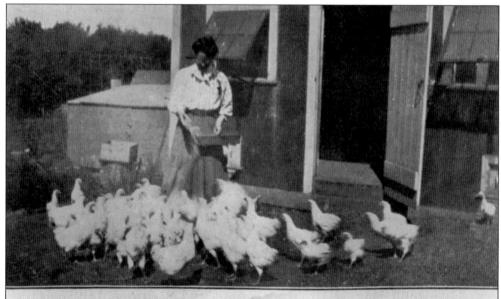

"Feeding the Chickens," Llewsac Lodge, Bedford, Mass.

Llewsac Lodge was a working farm, with some of the food harvesting and preservation done by women guests. The rest of the work was performed by a crew of paid farmhands. Eggs, chickens, fruit, vegetables, cream, and milk from the farm supplied the tables both at Llewsac and at the Willard Settlement in Boston. (JG.)

Storing Hay for Winter, Llewsac Lodge, Bedford, Mass.

The Llewsac Lodge barn had an unusual history. In the 1870s, John Butterfield, then the occupant of the property, arranged to have a mill in Fairfield, Maine, make and fit all the materials for the barn's construction and ship them to Bedford for assembly. This was considered so remarkable that, in 1913, the *Boston Globe* published an article about it.

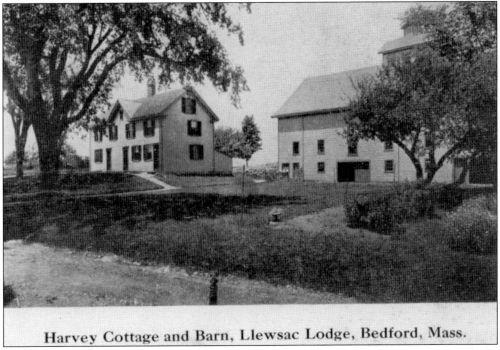

Harvey Cottage and Barn, Llewsac Lodge, Bedford, Mass.

Harvey Cottage was one of two cottages on the property. The first floor was used for a loom room, where guests could perform weaving to help pay for their stay. The second floor provided housing for the farmhands. The other cottage was a small building with only two rooms.

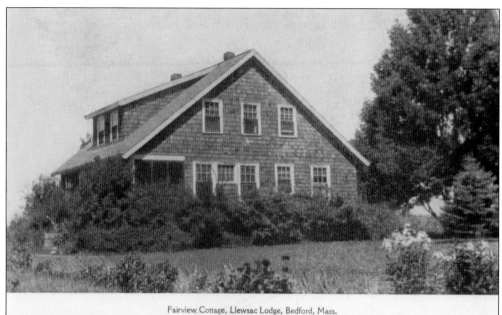

Fairview Cottage, Llewsac Lodge, Bedford, Mass.

Harvey Cottage caught fire and burned down on January 27, 1924, on a night when the weather was 16 degrees below zero. The farmhands who lived in the cottage were left temporarily homeless. Two new cottages were built that year. Fairview Cottage, seen here, might have been one of them.

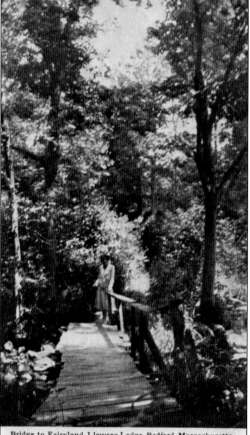

Bridge to Fairyland Llewsac Lodge, Bedford, Massachusetts

In 1917, the house across the street from Llewsac Lodge was purchased to create the Nellie Frank Hill Camp. This institution was dedicated to girls aged 12 to 20 who belonged to the Willard Settlement clubs in Boston. The girls spent part of their time doing kitchen and garden work and the rest in amusements on the grounds. The woodland along the Shawsheen River was considered so delightful that it was dubbed "Fairyland." (CWV.)

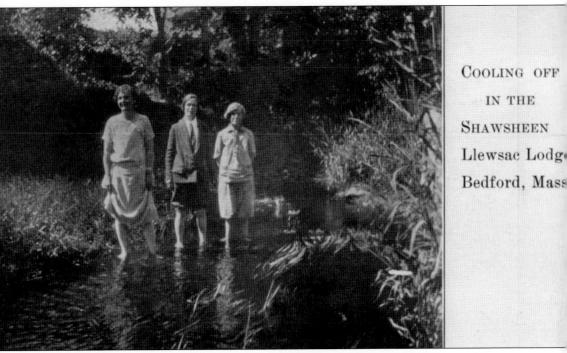

COOLING OFF

IN THE

SHAWSHEEN

Llewsac Lodge

Bedford, Mass

In the days before air-conditioning, summer visitors from the hot, crowded streets of Boston must have found Llewsac Lodge's shady walks, fresh breezes, pine-scented forest, and the cool waters of the Shawsheen River delightful indeed. The opportunity to walk alone somewhere must have seemed a treat to many of the women. (CWV.)

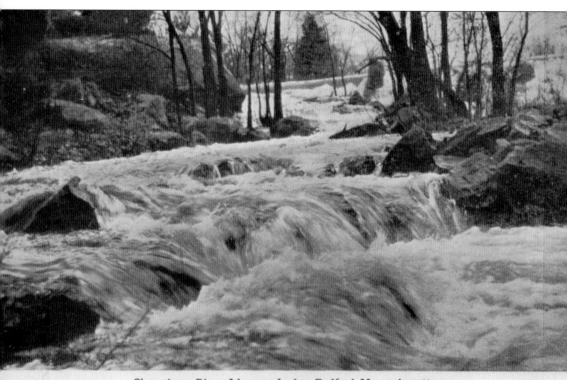

Shawsheen River, Llewsac Lodge, Bedford, Massachusetts

A short way down Old Billerica Road, a dam on the Shawsheen River provided water power for a sawmill. In this rare view, water courses down from the dam. The Town of Bedford bought the mill site and demolished the dam in 1947 to improve drainage along the river. (CWV.)

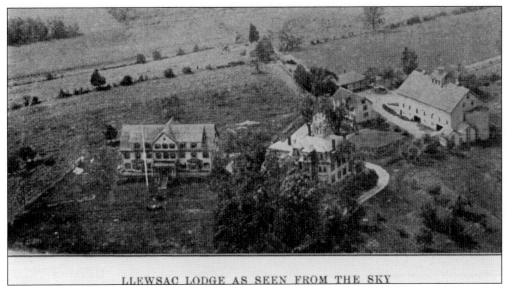

LLEWSAC LODGE AS SEEN FROM THE SKY

Both Llewsac Lodge and Llewsac Industries did so well that, within three years of its founding, Llewsac needed more dormitory rooms and more work space. A new building went up in 1913. Nellie Evelyn Cook Hall, also known as Main House, was named for a benefactor of the institution and a personal friend of Caroline Caswell. (BHS.)

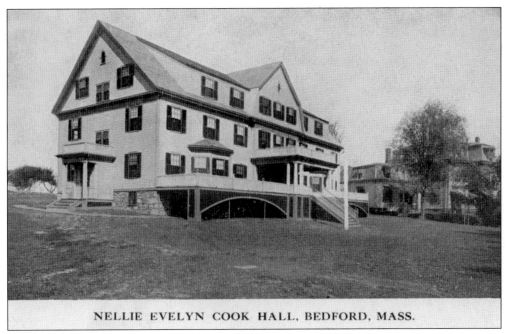

NELLIE EVELYN COOK HALL, BEDFORD, MASS.

Nellie Evelyn Cook Hall was constructed in 1913 at a cost of $20,000. It was enlarged three years later with the addition of another floor containing 11 rooms. One resident wrote to a friend, "I am glad every minute that I am here. It is beautiful here, an ideal country estate. There are about fifty here, but everyone can be as quiet as they choose."

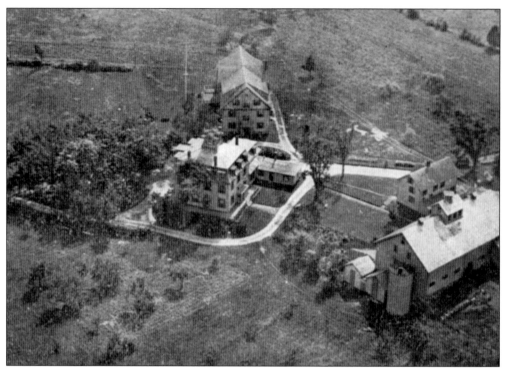

The sender of these two postcards was a frequent guest who wrote about her experiences at Llewsac: "There are 30 cows here in this barn. All [guests] have rich milk twice a day and lots of cream. This place has about 185 acres in cultivated lands—gardens, fields, woodlands, and a beautiful river across the road. . . . It is farming on an immense, as well as scientific scale, and they plan to raise 50% of table expenses right here. The acres of garden are a sight to behold! The place is becoming quite dear to me as well as to hundreds of other women who come here year after year and several *times* a year, I find." (Above, author's collection; below, LD.)

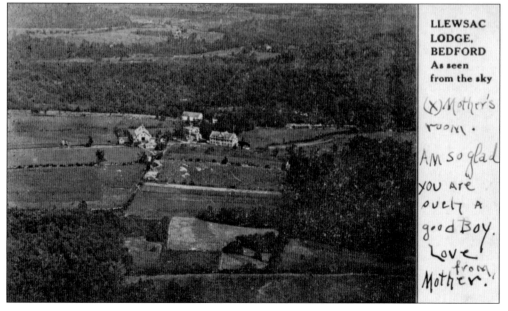

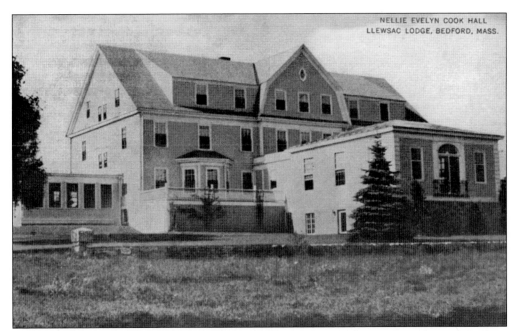

Llewsac Lodge continued to grow. In 1937, Nellie Evelyn Cook Hall, also known as Main House, was enlarged. The new space featured a sunroom in the extension on the south side (left) and a glass-enclosed dining hall in the extension on the east side (right). There were also new kitchens.

This is the sunny, new dining room following Cook Hall's 1937 addition. The rules of Llewsac Lodge specified that each guest had to be able to take care of her own room and attend meals in the dining room. The new dining room was large enough to allow all the guests, staff, and farmhands to sit down to Christmas dinner together.

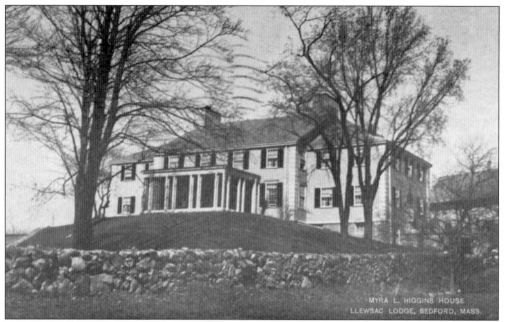

In 1938, the original mansion—it had been called Llewsac Lodge in its early years and later was called Myra L. Higgins House—was demolished and replaced with a new residence hall, also called the Myra L. Higgins House. The new Higgins House is seen here. Projecting from the center is a sunporch.

After the new Higgins House was built, a drive from Old Billerica Road was constructed to run up to Cook Hall and Higgins House. The approach was lined with maple trees, some of which still stand. There was also an underground tunnel connecting the two buildings. The drive is no longer in use.

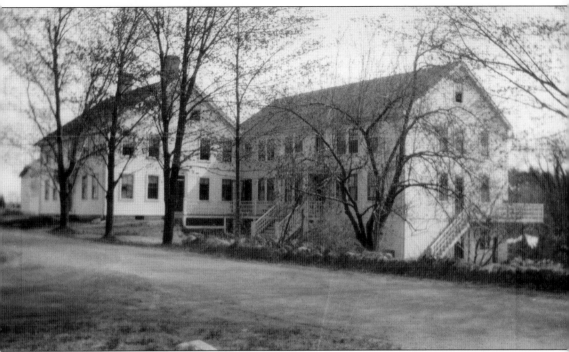

In 1925, Llewsac Lodge received from Anna Read a substantial bequest to be used as a memorial for her sister, Marietta Worthen. With this bequest, Llewsac Lodge converted the farmhouse across the street, which had been used as a summer camp for girls, into a home for women who needed some assistance with personal care. An ell was added. The Marietta Worthen Memorial Home for Convalescents, shown here, opened in 1927. By 1946, the building was in such poor condition that the home was closed and the building sold. The main part of the building (left) is still standing at 109 Old Billerica Road and, having been bought back, is used by Carleton-Willard Village as a guest house. The ell was detached and moved a few yards away, to 99–101 Old Billerica Road, where it is now a private home.

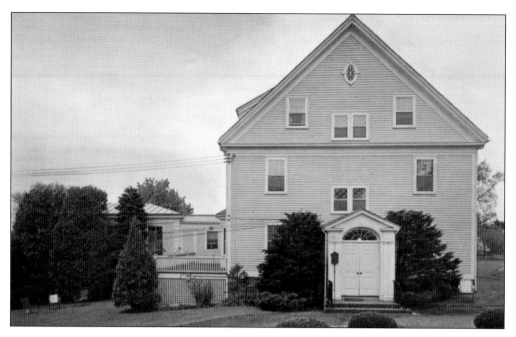

In the 1970s, the Frances Willard Homes (the new name of the Frances E. Willard Settlement) entered into discussions with Elizabeth Carleton House, a home for aged men and women, about combining their resources into a single retirement community. Thus was born Carleton-Willard Village, the third institution on Old Billerica Road to bear the stamp of Frances E. Willard. Much new construction was required. Nellie Evelyn Cook Hall (above), built in 1913, was demolished. Myra Louise Higgins House (below), built in 1938, was moved to its current location. Carleton-Willard Village officially opened in 1982. Today, Carleton-Willard Village is a vibrant and growing community.

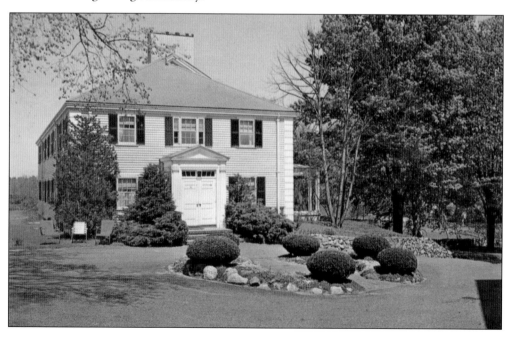

Six

LEXINGTON PARK

Lexington Park was a seasonal attraction on the Lexington & Boston Street Railway line that ran between Arlington Heights and Lowell. Visitors from all over the area could take the trolley to the 48-acre woodland park that lay mostly in Bedford and partly in Lexington. At first, its offerings were fairly simple—paths through cool, shady woodlands, picnic grounds, a small zoo, refreshment stands, a women's building, and an outdoor theater with vaudeville performances.

Lexington Park's opening day, July 21, 1902, was late in the season and the coldest summer day in years, yet the park had what the people wanted. Customers arrived in numbers that astonished the management. Within days, the streetcar company had to put extra cars on the route, but even so, not everyone could get a seat. Lexington Park was a roaring success.

New features were added each year, especially after John T. Benson became the manager in 1904. Within a few years, the park offered a wide array of amusements, including roller-skating, a merry-go-round, an electrical arcade, a shooting gallery, a toboggan slide, a bowling alley, electric fountains, a swing court, an observation tower, a dance hall, and more. Benson also expanded the animal collection. Lexington Park did well for a number of years but encountered increasing competition from movie theaters and other popular entertainments.

The 1918 season ended badly. In August, a park visitor died after being mauled by a bear. Labor Day weekend, which should have brought large crowds, saw the park deserted because of a strike by streetcar workers. Far worse, autumn brought the horrors of the deadly worldwide influenza epidemic and, with it, restrictions on public gatherings. Lexington Park closed for the season and never opened again. In 1921, the buildings were demolished and the land began to be sold for building lots.

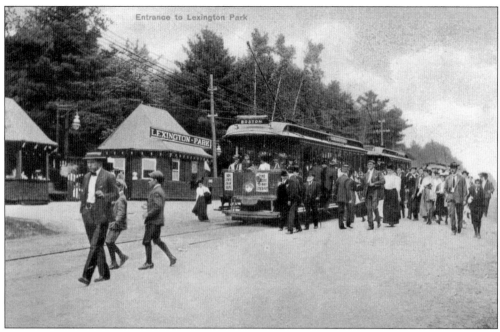

The Lexington & Boston Street Railway made it easy to get to Lexington Park. In 1909, just 25¢ bought a round-trip ticket from Boston plus park admission. City dwellers could escape the hot, crowded streets and have a delightful day in the country. As many as 11,000 people a day came to the park.

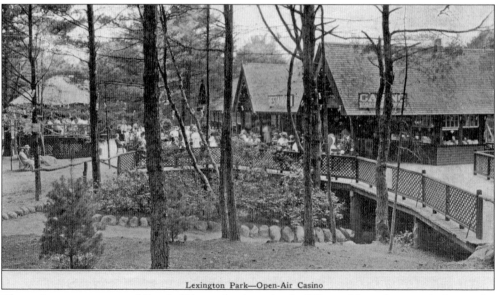

The casino was not a gambling hall but a food service building with a takeout window and a "popular price restaurant" offering nonalcoholic "temperance beverages" and meals for as many as 300 diners at a time. Prices were kept low to draw more patrons. Cows and hens on the property provided milk and eggs, and a neighboring farm provided vegetables.

The bandstand just outside the restaurant, which opened in 1904, provided another venue for performers. The diners seen here are seated on the porch of the casino. The Edna F. Simmons Ladies Orchestra gave two concerts a day here for many years. The novelty of seeing women engaged in a traditionally male occupation must have been very interesting to park guests.

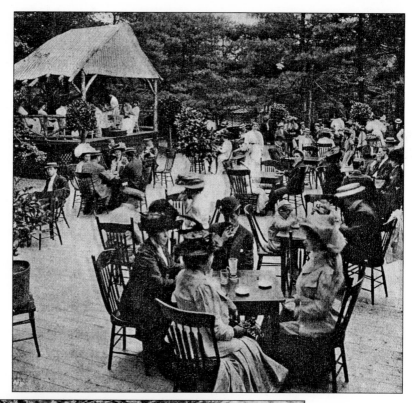

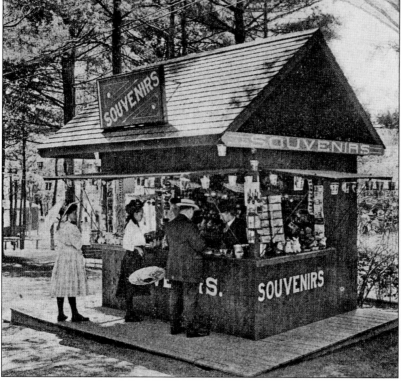

Once through the gates, guests could enjoy the day without spending more money—that is, if they could resist the souvenirs and snacks. Concession stands offered soda made on the premises, popcorn, and, of course, ice cream. Note the rack of postcards at the right-hand end of this souvenir stand. Lexington Park sold them in huge quantities.

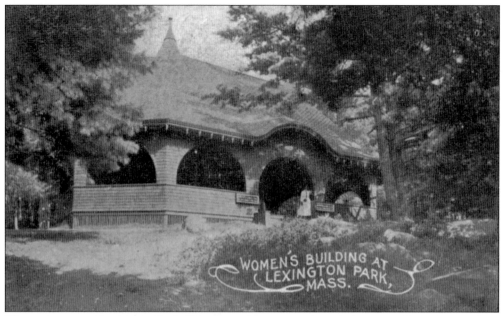

Women guests at Lexington Park did not need to worry about being away from the comforts of home. At the women's building, they could get away from the crowd, rest, put a baby to sleep in a crib provided by the park, and attend to other feminine matters. A matron provided whatever assistance was needed.

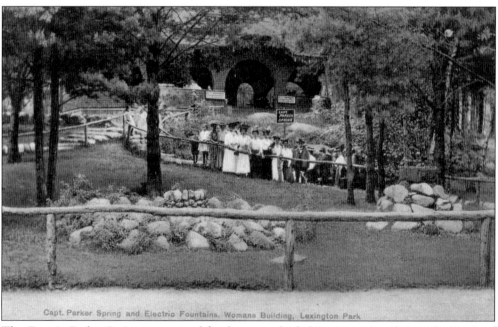

The Captain Parker Spring was named for the man who led Lexington's militia at the Battle of Lexington. The park's advertising emphasized the historic area through which the customers passed as they rode the trolley from Arlington Heights. Even the name "Lexington Park" was meant to strengthen the connection with history, overlooking the fact that most of the park was located not in Lexington but in Bedford.

Lexington Park's natural setting, especially its pine grove, was one of its strongest attractions. About half of the grounds were wooded. The guarantee of shade—particularly when sitting at the open-air theater—the scent of pines, cool breezes, and paths to ramble were allurements. Other resorts also offered zoos, restaurants, and vaudeville shows, so Lexington Park's owners decided to emphasize its woodland features. The forest also made it possible for many large groups to have picnics at the same time without encroaching on one another. A newspaper article described an outing to the park as "the pleasantest relief from the heat at the least expenditure of money."

Scene in Lexington Park, Lexington, Mass.,

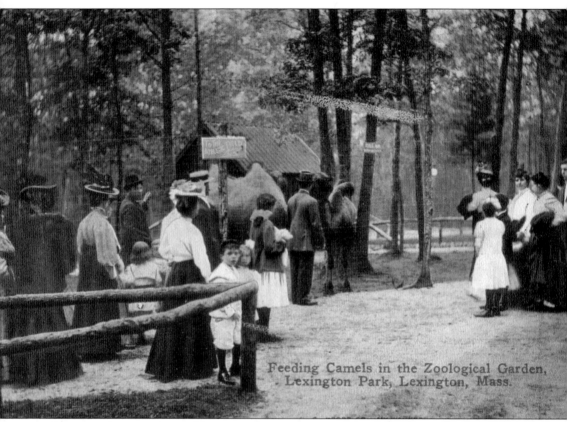

Feeding Camels in the Zoological Garden, Lexington Park, Lexington, Mass.

The zoo was a marvel. In addition to Siberian camels, Lexington Park had, at various times, white fallow deer, axis deer, Virginia deer, elks, zebus, aoudads, buffalo, turkey buzzards, wolves, parrots, monkeys, yaks, nylghaus, llamas, foxes, aquarium fish, and assorted birds. There was a small, separate children's menagerie and an elk park. The monkey cage was reached only by passing through the electrical arcade, two attractions that young people surely found irresistible. Grass cut in the park fed the herbivorous animals. Each winter, when the park was closed, manager John T. Benson took the animals to Cuba and exhibited them there. An acknowledged expert, Benson devoted his life to studying animals and the best methods for maintaining them in captivity, traveling worldwide to gain knowledge of new methods. In 1911, he was appointed the curator of the new Franklin Park Zoo in Boston.

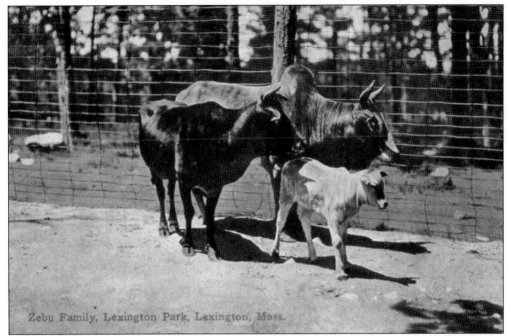

Zebu Family, Lexington Park, Lexington, Mass.

A publicity piece released just before the opening of Lexington Park read, "The zoological garden covers a larger area than any other in New England, and is equipped in an ideal manner with natural enclosures for a great variety of rare animals. A special attraction is the sacred cow from India," in reference to the zebu.

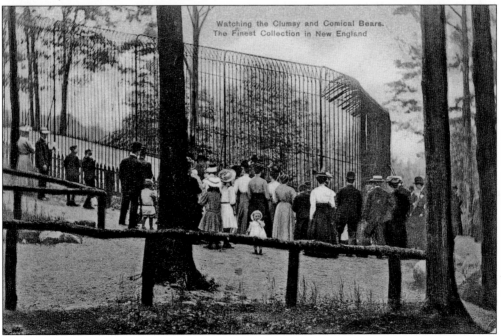

Watching the Clumsy and Comical Bears. The Finest Collection in New England

Who can resist zoo babies? In 1903, the crowds took delight in two bear cubs named Teddy and Kaiser. The park's bears lived in luxurious quarters. The 60-foot-by-40-foot bear pit, with an 18-foot fence, two separate dens, and an eight-foot pool, was built at a cost of $2,400.

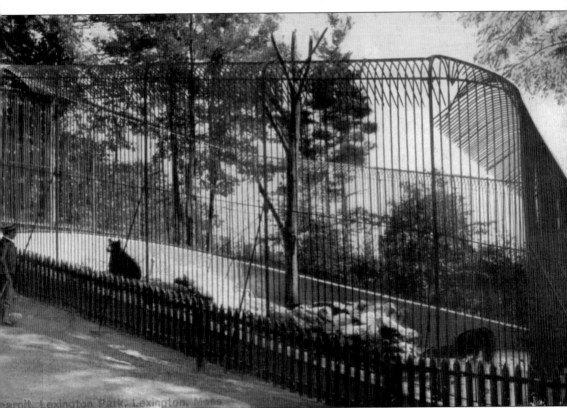

The bears' fence was there for a reason. On August 10, 1918, Carl Hulner of Billerica dropped or threw a bag of peanuts into the bear cage. Reaching into the cage to retrieve the peanuts, he accidentally struck the bear on the nose. The angered bear clawed Hulner's arm so badly that he died at Symmes Hospital several days later. That was not the first time Lexington Park's zoo had had trouble. On the night of September 28–29, 1904, someone slipped in and released three bears, a bull buffalo, and two wolves. The overfed bears did not go far and were easily persuaded to return to their quarters. The buffalo put up a fight but was safely recaptured. The escaped wolves, however, terrorized Bedford and neighboring communities for several days and attacked farm animals. On October 1, Alden Brown of Bedford shot and killed one of the wolves on Springs Road. On October 3, Charles E. Taylor of Woburn shot and killed the other in Burlington.

EVA SCOTT

After the first few years, plays became an increasingly important offering of the rustic stage. By 1915, there was a resident stock company to perform a new play each week. On August 28, 1916, Eva Scott and her own stock company opened at the park, presenting a play called *Just Plain Polly*.

KING.

J. W. GORMAN'S HIGH DIVING HORSES.

Impresario J.W. Gorman booked vaudeville acts for Lexington Park, Norumbega Park, and other places of popular entertainment. In July 1910, he brought his premier act for a spectacular week. As reported by the *Boston Daily Globe*, "Tremendous crowds went to Lexington Park yesterday to see the famous diving horses, King and Queen," who would mount a tower and "bow to the applauding multitude before making the picturesque plunge."

This map makes it clear that city dwellers could easily get to Lexington Park. There were also plenty of historic sites on the line, as detailed in the Lexington & Boston Street Railway's guidebook, *Route of the Minute Men*. The section on Bedford mentions the Town Common, the library, the Bedford Flag, the Stearns House, Fitch Tavern, Pollard Tavern, the Job Lane House, and Bedford Springs.

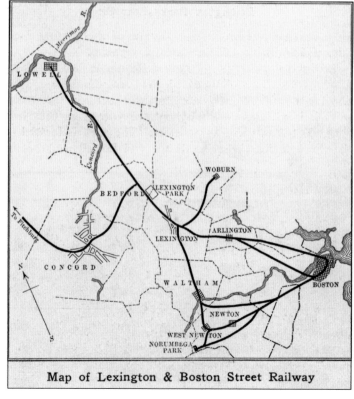

Map of Lexington & Boston Street Railway

Seven

THE MILITARY

Bedford has been the home of three military institutions: Hanscom Airport, a Nike missile site, and the Veterans Administration Hospital.

Hanscom Airport began as the Bedford Airport. For many years, the state had urged construction of an airport at Bedford as a backup to the East Boston airport, but Bedford residents strongly opposed the plan. The deadlock was broken by the federal government, which saw the Bedford Airport as a military necessity and offered to pay for construction of a state-owned airport if the state would provide the land. The state took approximately 500 acres in Bedford, Concord, and Lincoln by eminent domain. Ground was broken on July 17, 1941. Work continued around the clock. In July 1942, the airport was leased to the Army Air Forces. In 1943, it was named Laurence G. Hanscom Airport, in honor of a *Boston Globe* reporter who had lobbied for the establishment of the Bedford Airport. Today, Hanscom is a civilian airport and is still owned by the state, but the Air Force maintains facilities and is permitted to use the runways as needed.

From 1956 to 1961, a facility on Old Causeway Road housed launchpads for Nike anti-aircraft missiles. It was one of several Nike sites that ringed Boston as part of the national defense system.

Bedford's US Veterans' Hospital was opened in 1928 as a neuropsychiatric hospital for male veterans. In 1978, the hospital was renamed the Edith Nourse Rogers Memorial Veterans Administration Hospital, in honor of a US congresswoman who was noted for her support of the hospital and veterans. The hospital is in active use today.

In 1942–1943, Hanscom Airport was a training ground for P-40 pilots of the 85th and 318th fighter squadrons who went on to fight in Europe and North Africa. Because the Curtiss P-40 Warhawk was rugged and relatively inexpensive, it was mass-produced after Pearl Harbor until more advanced aircraft could be produced in sufficient numbers.

This dramatic nighttime scene of P-40s in flight at the Bedford Army Air Base during World War II is somewhat erroneous. P-40s were fighter aircraft rather than bombers. Also, they were rarely flown at night until very late in the war and seldom even then. This postcard may be taken more as a sentimental representation than as documentary history.

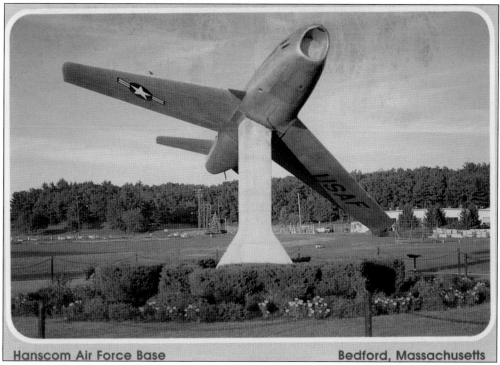

Hanscom Air Force Base Bedford, Massachusetts

The F-86 Sabrejet, America's first swept-wing aircraft, played a crucial role in combating MiG fighter aircraft in the Korean War. F-86s were stationed at Hanscom from 1955 to 1960. The one on this postcard was mounted as a static display at Hanscom in 1980. In 2000, it underwent restoration work that had to be done in place, because the jet was too heavy to be dismounted.

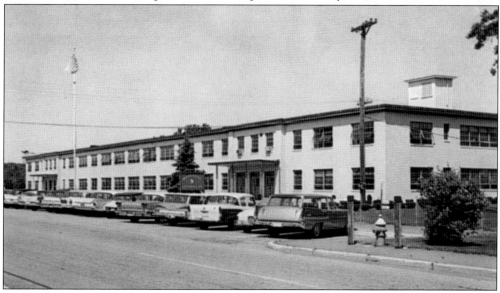

Building 1600, constructed in 1952 to serve as headquarters of the Air Force Cambridge Research Center, is one of the oldest buildings at Hanscom Air Force Base. Seen here, it was the headquarters of the 3245th Air Base Wing. Today, it is used as office space for the Electronic Systems Center. (BHS.)

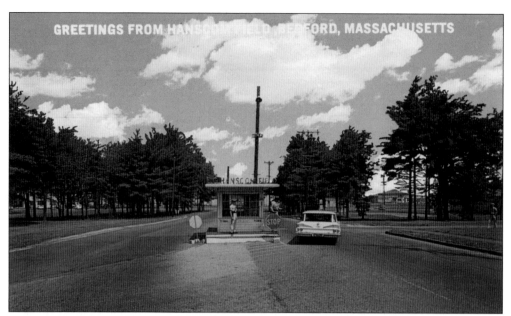

In Hanscom Airport's early days, there were many routes of entry. After access became limited, the gate shown here became the main entrance. This site is not at the perimeter but far inside Hanscom's grounds, at the intersection of Vandenberg Drive and Marrett Street (not to be confused with Marrett Road), where a replica P-40 aircraft is on display. There is no longer base access from Marrett Street.

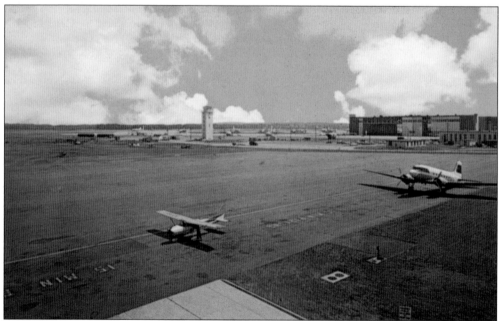

The taxiway in the foreground was used to enter the runway on the southwest corner of Hanscom. The hangar at the right was constructed in 1952. In this image, the control tower stands alone. The tower has since been replaced, and a number of new buildings stand nearby. Today, the runways are mostly used by civilian aircraft. Hanscom is one of the busiest airports in New England.

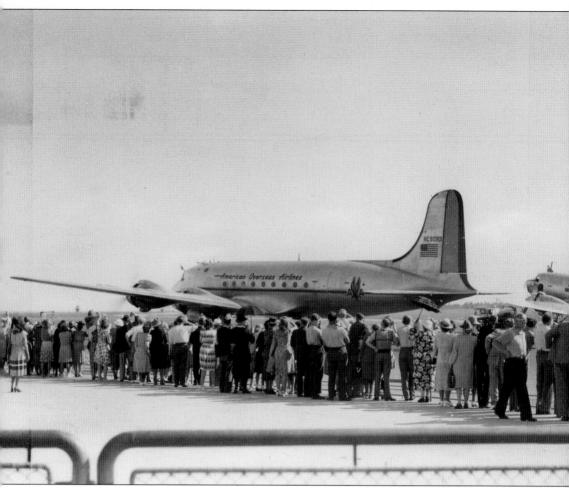

Aviation history was made at Hanscom Airport on October 24, 1945, when the American Overseas Airlines DC-4 flagship *London* (a sister aircraft to the one seen here) left Hanscom Field for London. It was the first scheduled commercial transatlantic airline trip in history. It flew from Hanscom rather than Logan Airport because the latter was not yet capable of handling such flights. After refueling stops in Newfoundland and Iceland, a brief visit to Shannon Airport, and a struggle through a storm along the English coast, the *London* landed at Hurn Airport in England 18 hours and 20 minutes after leaving Bedford. The next morning, it left for the return trip to Bedford, but because of bad weather it was forced to land at LaGuardia Field, New York, instead of Bedford. Within a few months of this successful trip, Trans World Airlines was flying from Bedford to Shannon, Paris, Lisbon, Madrid, Rome, and Cairo. It was not until June 1946 that Logan Airport was able to handle overseas flights.

From November 1956 to December 1961, Bedford was home to a Nike antiaircraft missile site. Launchpads for Ajax missiles were located off the end of Old Causeway Road. As many as 12 missiles at a time could be mounted and made ready to launch. The missiles did not carry nuclear warheads. A 29-acre site on Davis Road had been taken by eminent domain to construct a control facility as well as staff housing. In 1958, a housing development of 16 single-family homes on Pine Hill Road, Lewis Road, and Michelson Street replaced the Davis Road housing. These houses are still standing and are owned by the Coast Guard. The Davis Road control facility and houses have been demolished, and the land on which they stood has become part of the Revolutionary Ridge housing development. The former missile installation on Old Causeway Road is now the Concord Field Station, a research facility of Harvard University.

A PUBLIC HEARING is called for

Saturday, November 14, at 8 o'clock P. M. in the Town Hall, to consider the proposed locating of a Veterans' Hospital in Bedford. A full and free discussion is hoped for, and a vote will be taken.

JOHN KIRKEGAARD
CLAUDE A. PALMER } *Selectmen of Bedford*
MERTON L. WINCHENBAUGH

This 1925 notice reflects years of uncertainty over siting a new veterans' hospital in Bedford. As early as 1917, the Veterans Bureau had considered several locations in Massachusetts. In 1923, federal authorities announced that Bedford would be the locale and even began surveying the proposed site, but they did not purchase the Howe Farm and the adjoining Dr. Cross estate until 1927. (BHS.)

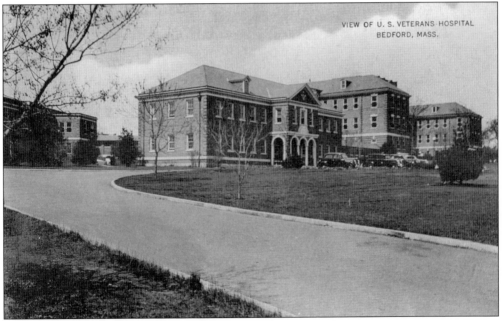

Construction of the veterans' hospital began in 1927. The building in the center with the arched entryway was the administration building. To the right can be seen the two front wings of the infirmary building. The flat-roofed building on the left was the kitchen and dining hall. These and 12 other buildings were in place when the hospital was formally opened in 1928. A further nine buildings were already planned.

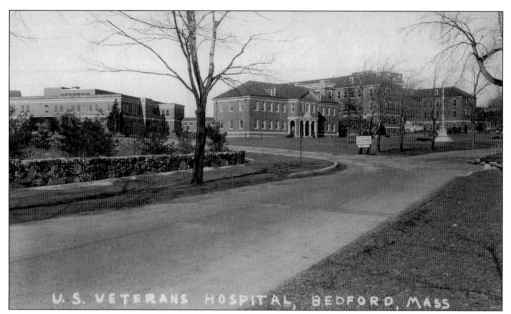

In July 1928, Dr. William M. Dobson, medical director of the new US Veterans' Bureau Hospital in Bedford, announced that the first 270 patients had been transferred from the West Roxbury veterans' hospital. Formal dedication ceremonies were held on September 16. Plans for construction of additional buildings were in place to increase the hospital's capacity beyond its original 350 beds.

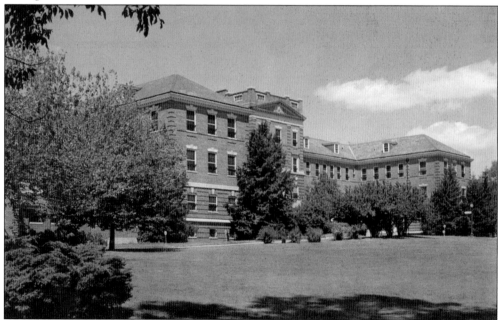

This is the infirmary, the main building at the US Veterans' Hospital when it opened in 1928. Other buildings in place at the time were the administration, dining, recreation, and continued treatment buildings, all connected by covered walkways. Attendants' quarters, a laundry and storehouse, and a garage were located on the same side of Spring Street. Across the street were medical officers' headquarters and housing for married officers and nurses.

The recreation building was one of the original group of structures opened at the veterans' hospital in 1928. Recreation was considered to be an essential part of rehabilitation. In 1929, the Veterans of Foreign Wars donated two bowling alleys. The following year, they donated an indoor golf course for disabled patients, complete with slopes, sand traps, water hazards, and natural plants surrounding the greens.

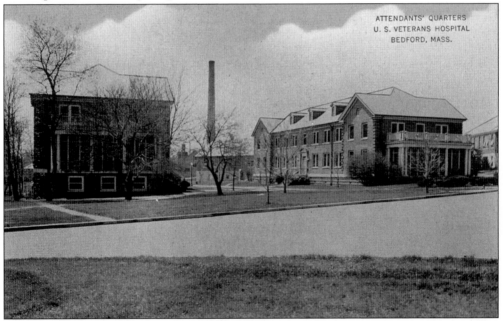

The two attendants' quarters were built in 1930 (left) and 1928. As soon as it opened, the hospital was the biggest employer in Bedford. It also swelled the town's population. Most of the original staff were transferred from other locations rather than hired from among Bedford's population, and housing had to be found for them. The hospital provided its own living quarters for doctors, nurses, orderlies, and managers.

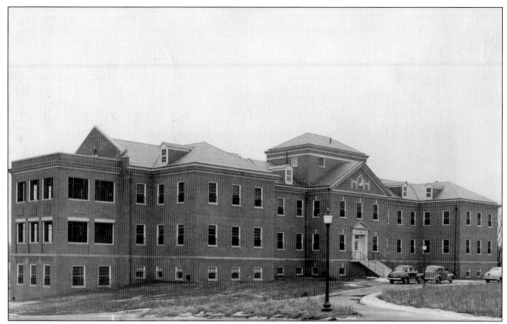

The women's building was formally opened on March 29, 1947. It is believed to be the first veterans' hospital building in the country built specifically for female veterans. It was located a little distance from the rest of the hospital and was self-contained, having its own dining facilities and a beauty parlor. It is now an office building.

This pond near Springs Road was once used for skating. In the background can be seen the tops of Buildings 3 (left), 1, and 2. In the 1960s, the pond was filled in and the stone walls were removed. Today, the site is an athletic field behind Parking Lot 1. The three pine trees across the pond are still living.

Eight

RESIDENTS AND VISITORS

Like any community, Bedford is proud of its connections with the famous, the accomplished, and the memorable people of the world. A few of its native sons have achieved fame. Three come to mind. Wallace G. Webber was one of the founders of the Paine Webber and Company investment house, which operated under that name until it was bought by another company in 2000. Thompson Maxwell, who grew up in Bedford but had moved to New Hampshire, took part in the Boston Tea Party. Rev. William A. Stearns, a son of Rev. Samuel Stearns, became a president of Amherst College.

Other brushes with greatness have come from visitors to Bedford. Many US presidents and other high officials have flown into Hanscom Airport as an alternative to landing in Boston. One was Gen. Douglas McArthur when he returned from World War II; he was driven along a parade route all the way from Bedford to Boston. Entertainers of note have visited over the years; for example, both Arthur Fiedler, who came repeatedly, and Ted Shawn, with his dance company, provided entertainment for patients at the veterans' hospital in its early years. Mayors of Bedford, England, have honored the town with their presence on special occasions, such as the town's US bicentennial celebrations in 1976. Bedford's proximity to Concord made it almost inevitable that some of the Concord luminaries should have visited. Ralph Waldo Emerson was one of the speakers when Bedford unveiled its Civil War soldiers' monument in 1874. Emerson and Bronson Alcott were guests at Bedford's sesquicentennial in 1879. Henry David Thoreau summarized his Bedford experiences with the line, "Bedford, fair Bedford, I shall not soon thee forget."

Some of Bedford's residents and visitors found their way onto postcards.

Edward Everett Hale.

(iPc) 5534|14

Edward Everett Hale was a superstar in his day, famed as a writer, Unitarian minister, humanitarian, and abolitionist. He is best remembered for his short story "The Man Without a Country." As president of the Willard Hospital on Old Billerica Road, he sometimes visited Bedford. He also contributed to the patients' newsletter, the *New Leaf.*

```
     Anthony - Hunt - Hamilton Post No. 221
              The American Legion

                     Bedford, Mass., June 18,1920

There will be a meeting at the Town Hall, Bedford,
Mass., Thursday, June 24, 1920 at 8:00 o'clock P.M.
in connection with the formation of a Ladies'
Auxiliary of this Post of The American Legion.

Speakers:   Rev.J.Vanor Garton of Bedford
            Joseph R. Cotton of Lexington
            Dr. James J. Walsh of Lexington
Music                          Everyone invited
A. E. Carson                   W. A. Wilkins
     Post Adjutant                  Post Commander
```

Bedford's Anthony-Hunt-Hamilton Post 221, American Legion, is named for three Bedford men who died in World War I. Stanley Thomas Anthony, 24 years old and a sailor, died when the USS *Chauncey* was accidentally rammed by an allied ship. Hugh I. Hunt, 19, a soldier, was fatally wounded in action in France. William Walter Hamilton, 37, a career Marine, was also killed in France. (BHS.)

In 1912, Dr. Albert Pfeiffer of Bedford married actress Alexandra Carlisle in London. She was well known on the London stage, having appeared in productions at the Drury Lane and Garrick theaters. The couple soon left England for America. They lived for a time in Bedford. She continued her stage career in Boston and New York, achieving an even wider fame. In 1920, she put her talents to work as one of the first woman delegates to the Republican National Convention, where she made the seconding speech for Calvin Coolidge. Asked afterward for her impressions of the convention, she said that the men talked too much and that "when the women take a more active part, they will see that this mistake is corrected." She died in 1936 and is buried in Shawsheen Cemetery.

4073 H MISS ALEXANDRA CARLISLE. ROTARY PHOTO. E.C.

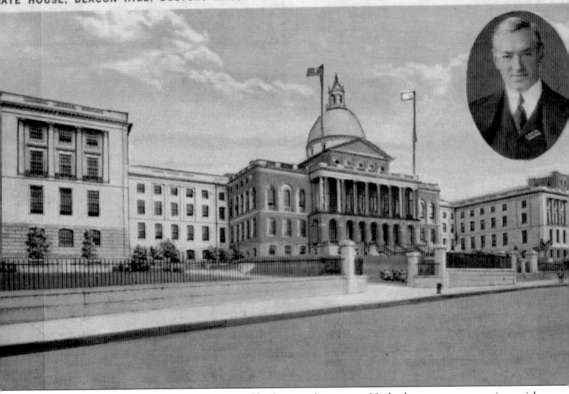

Politician James M. Curley came to Bedford more than once. He had a warm connection with the veterans' hospital. In 1931, the *Daily Boston Globe* said, "Mayor Curley has purchased two white swans from John Benson, Inc., of Nashua, N.H., for presentation to the United States Veterans' Hospital at Bedford. The swans will be placed in a pond on the hospital grounds." In 1932, he was made an honorary life member in the organization of Patients and Veterans of the Administration Hospital. As a candidate for governor, the former Boston mayor came to Bedford to give a stump speech before a gathering of the Boston Letter Carriers Old-Timers' Outing Association at McGovern's Grove on September 9, 1934. The grove was part of the McGovern farm on Hartwell Avenue. Curley's reputation as a corrupt politician survives in the slogan, "Vote often and early for James Michael Curley."

St. Theresa's Convent in Bedford was a training center for nuns who became foreign missionaries. Richard Cardinal Cushing, seen here, had a special regard for St. Theresa's and visited a number of times. On August 5, 1945, he led 2,000 people on a Pilgrimage of Peace to the grotto on convent grounds. The grotto site is now part of Middlesex Community College.

RALPH·WALDO·EMERSON·

Ralph Waldo Emerson was invited as a celebrity guest at Bedford's sesquicentennial celebration in 1879. When eager Bedford residents asked the 76-year-old Emerson to follow the main speeches with a few words of his own, he replied, "I am sorry that I am not able to respond. I can understand with joy the speeches that I hear, but I cannot make one."

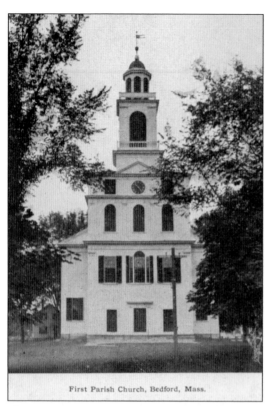

First Parish Church, Bedford, Mass.

This postcard of the Unitarian church was printed by the Bedford Print Shop. Charles C. Farrington began the business in his home by making postcards of his own photographs of local points of interest using a treadle printing press. After moving to larger quarters, he printed materials for the Sweetwater Hotel and labels for Hayden's Viburnum Compound.

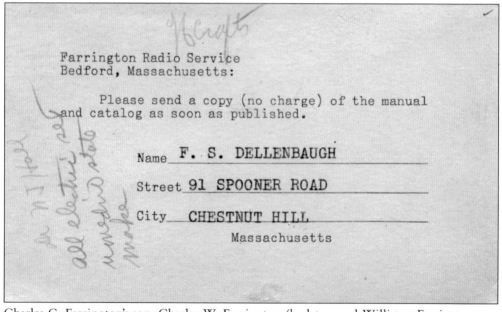

Farrington Radio Service
Bedford, Massachusetts:

 Please send a copy (no charge) of the manual and catalog as soon as published.

Name F. S. DELLENBAUGH

Street 91 SPOONER ROAD

City CHESTNUT HILL

 Massachusetts

Charles C. Farrington's son, Charles W. Farrington (he later used Williston Farrington as a pen name), started the Farrington Radio Service in a room above his father's print shop. He assembled and sold battery-operated radios, using cabinets that had been made in the workshops of New England Nurseries and, later, by the St. Coeur factory in Cambridge. The coming of AC-powered radios put an end to the Farrington Radio. (RA.)

Wallace Goldsmith (1872–1945) of 71 Concord Road was a noted cartoonist and illustrator. For many years, he drew cartoons for newspapers in Boston and elsewhere, mostly for the sports pages. He also illustrated a number of books. He was particularly good at humorous pictures, like this comical postcard for Old Home Week in 1912. (BHS.)

John Hancock was a nephew of Lucy Hancock Bowes—the wife of Bedford's first minister, Rev. Nicholas Bowes—and first cousin to the Bowes children. It is likely, but unproven, that Hancock visited his relatives in Bedford. He definitely was involved with the Bowes family in one way—the Bedford Historical Society owns a document that Hancock signed in 1758 in regard to settling Reverend Bowes's estate.

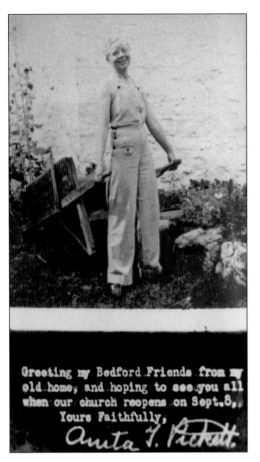

Greeting my Bedford Friends from my old home, and hoping to see you all when our church reopens on Sept. 8.
Yours Faithfully,
Anita T. Pickett

Anita Trueman Pickett (1881–1960) was a philosopher, poet, and radical thinker who became an acclaimed public speaker while she was still in her teens. Her richly varied spiritual life led eventually to her ordination as a Unitarian minister. She served as minister of the First Parish Church in Bedford from 1937 until 1942. (JG.)

Yours for Health
Lydia E. Pinkham

Lydia Pinkham, famed for her patent medicine, Lydia Pinkham's Vegetable Compound, lived for a few years in Bedford, along with her husband, Isaac, and their children. Their daughter Aroline was born in Bedford in 1857, before the family moved back to Lynn, Massachusetts. Lydia Pinkham did not begin selling her vegetable compound until 1876, but she had been giving it to friends, perhaps including some in Bedford, for many years.

122

Renowned composer Igor Stravinsky married Vera Sudeikine in Bedford on March 9, 1940, at the 564 Springs Road home of his friend and fellow Russian expatriate Dr. T.A. Taracouzio. The ceremony was conducted by Justice of the Peace Arthur Carson of Bedford. Stravinsky had come to live in America and was in the Boston area while teaching at Harvard during the 1939–1940 school year.

IGOR STRAVINSKY

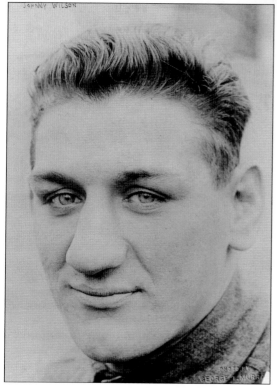

JOHNNY WILSON

Professional boxer Johnny Wilson had a gymnasium at the Bedford House hotel and used it as his training quarters in 1920 and 1921 for some of his most important fights. His manager, Marty Killerly, had him go for five-mile runs around Bedford. Wilson became the world middleweight champion by defeating Mike O'Dowd on May 6, 1920.

Governor Winthrop Arrives at Salem on the "Arbella"

★ 1630 ★

John Winthrop, the first governor of the Massachusetts Bay Colony, is shown on the *Arbella*, the ship that carried him to America from England. (Arbella Road in Bedford is named for his ship.) Although Winthrop visited, he never lived on the huge tract of Bedford land that was awarded to him for his services to the colony. The land stretched from the Two Brothers Rocks, near what is now the Billerica town line, south to today's Bedford Farms on North Road. It was inherited, still an untamed stretch of wilderness, by his grandson FitzJohn Winthrop. Job Lane, a housewright, acquired the land by building a house for FitzJohn Winthrop in Connecticut. How Job Lane, a resident of Malden in the Massachusetts Bay Colony, came to meet Connecticut resident FitzJohn Winthrop is unknown. The 1664 contract and the 1664 deed for the land in Bedford are both in the possession of the Bedford Historical Society.

In 1916, a film crew came to the Penniman–Stearns mansion, 26 The Great Road, to record scenes for a silent movie based on the play *Nathan Hale* by Claude Fitch. Called *The Heart of a Hero*, the film was directed by Emile Chautard and released on November 6, 1916. Actor Robert Warwick (1878–1964) played Nathan Hale, and Gail Kane (1887–1966) played the girl he loved, Alice Adams. Kane was much in demand at the time of her visit to Bedford, making 20 films between 1913 and 1918, but her career lagged after that. Warwick's career continued. Late in his life, he appeared in several television shows, including a 1960 episode of *The Twilight Zone* called "The Last Flight."

ROBERT WARWICK
WORLD STAR

GAIL KANE
WORLD STAR

BIBLIOGRAPHY

Boston Globe (1872–1981). ProQuest Historical Newspapers.

Brown, Abram English. *History of the Town of Bedford, Middlesex County, Massachusetts*. Bedford, MA: privately published, 1891.

Brown, John F. *Remembered in Bedford, Massachusetts*. Burlington, MA: DSA Printing & Publishing, 2000, 2006.

Brown, Louise K. *A Revolutionary Town*. Canaan, NH: Phoenix Publishing, 1975.

———. *Wilderness Town, the Story of Bedford, Massachusetts*. Published privately, 1968.

Farrington, Williston. *An Awesome Century*. Bedford, MA: Bedford Historical Society, 2006.

Kelly-Broomer, Kathleen. *Historic Properties and Neighborhoods of Bedford, Massachusetts*. Bedford, MA: Bedford Historical Society, 2005.

Mansur, Ina. *A New England Church 1730–1834*. Freeport, ME: The Bond Wheelwright Company, 1974.

Mansur, Ina and Lawrence. *A Pictorial History of Bedford, Massachusetts, 1729 to Modern Times*. Barre, VT: Modern Printing Co., Inc., 1992.

McDonald, Sharon Lawrence. *The Bedford Flag Unfurled*. Burlington, MA: DSA Printing & Publishing, 2000.

Town of Bedford, Massachusetts. *Bedford in the World War*. Bedford, MA: Bedford Historical Society, 2009.

INDEX

DISCOVER THOUSANDS OF LOCAL HISTORY BOOKS
FEATURING MILLIONS OF VINTAGE IMAGES

Arcadia Publishing, the leading local history publisher in the United States, is committed to making history accessible and meaningful through publishing books that celebrate and preserve the heritage of America's people and places.

Find more books like this at
www.arcadiapublishing.com

Search for your hometown history, your old stomping grounds, and even your favorite sports team.